IMAGES of America

SOUTH ORANGE REVISITED

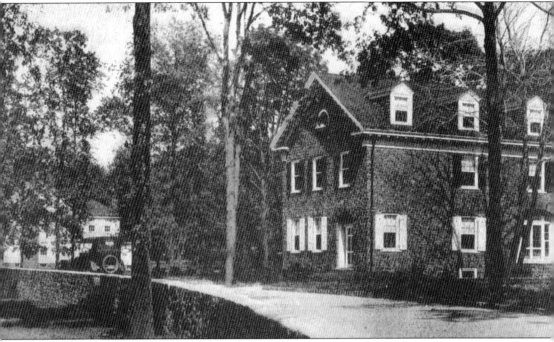

Known by residents and the U.S. post office as the "Private Road," this home at 510 Grove Terrace is shown around 1922 with an automobile parked out front. This small enclave is located in Montrose Park, and homeowners along this street are responsible for the upkeep of both the roadway and the park that runs in front of all of the houses. At the time this photograph was taken, the home was owned by George W. Bond Jr. (Courtesy South Orange Public Library.)

On the cover: Please see page 61. (Courtesy South Orange Public Library.)

IMAGES
of America

SOUTH ORANGE
REVISITED

Naoma Welk

ARCADIA
PUBLISHING

Published by Arcadia Publishing
Charleston SC, Chicago IL, Portsmouth NH, San Francisco CA

Printed in the United States of America

Library of Congress Catalog Card Number: 2006926490

For all general information contact Arcadia Publishing at:
Telephone 843-853-2070
Fax 843-853-0044
E-mail sales@arcadiapublishing.com
For customer service and orders:
Toll-Free 1-888-313-2665

Visit us on the Internet at www.arcadiapublishing.com

*This book is dedicated to my husband Steve and my brothers
David and Duncan Barth.*

CONTENTS

ACKNOWLEDGMENTS

Throughout the research process, Amy Dahn, president of Montrose Park Historic District Association, helped find facts, reviewed text, and worked with me to make this book possible. Amy's support as a friend, colleague, and editor has helped me present a book that I believe readers will find interesting and fun to read.

With the help of several people who have fond memories of South Orange, I uncovered new facts, documents, and photographs that have never before been presented. Peter Feketie, Sue Zurkow Frey, and Martha Riker Trundle took a chance and mailed in their original documents. Others who have generously shared their time and valuable papers and photographs include Eleanor Farrell, Nancy Heins-Glaser, Nancy Janow, Sam Joseph, Stella Locker, Alex Somers, David Thayer, Lt. Tony Vecchio, Lois Hradil, Mary Jane Waldron, Sr. Katherine McGlockim, and Donna Sartor. Just as he helped with *South Orange*, Seton Hall archivist Alan Delozier shared the university's collection of postcards, photographs, facts, a pair of white cotton gloves, and unlimited access to Seton Hall's archives. Thanks also to Melissa Kopecky, Ellen Columbus, and the staff at the South Orange Public Library.

Special thanks to David Barth who shared references to South Orange while reading O. Henry. Don Swick, Ron Kase, Duncan Barth, Nancy Heins-Glaser, and Cory Dahn helped me write accurate captions. Identifying vintage automobiles seemed impossible until I found Kim Miller, a librarian at the Antique Automobile Club of America Library and Research Center. Judy Garrett from the Berkshire Historical Society provided historic facts about Herman Melville.

The success of both the 2002 *South Orange* book and endorsement for this book is due in large part to the support of the Board of Directors of Montrose Park Historic District Association, including Bob Adler, Debbie Adler, Allison Brown, Amy Dahn, Maureen Gammon, Holly Gauthier, Agnieszka Grzybowska, Suzanne L'Hernault, Sam Moulthrop, Hilda Silverman, and Carolyn Tindall.

For the past several months, my husband, Steve, has helped streamline several processes by scanning and organizing hundreds of photographs. Double kisses to Steve for his support and significant contributions to *South Orange Revisited*.

INTRODUCTION

South Orange Revisited presents a time line of life in South Orange from 1860 until 1980. The evolution of life around the world was reflected by events in South Orange. I have included some notable global headlines and inventions to help all of us understand what was taking place around the world. The combination of the village's spacious lawns, mature trees, comfortable homes, and its proximity to New York City greatly influenced how people lived in the 1800s and influences how we live now.

While it is impossible to understand exactly how people lived in the mid-19th century, I hope this book provides a portrait of life in South Orange as far back as the 1860s. But first, let us briefly look at the first South Orange residents, the Hackensack branch of the Lenni-Lenape Native Americans.

Like many areas of northeastern New Jersey, Native Americans made North America their home until nearly 200 years after Columbus discovered America. In 1626, when Peter Minuit and his Dutch crew sailed into Manhattan Island, they introduced themselves to the "local residents" who we now know as Native Americans (the "first Americans"). Native Americans had been living on the island and the surrounding lands for centuries and were less than hospitable to the intruders.

Over the next 40 years, the Dutch settlers set up housekeeping around lower Manhattan, and eventually began to explore land beyond their home. Around 1666, they arrived on the shores of New Jersey via canoe and met the Hackensack branch of the Lenni-Lenape. Around that time, Capt. Robert Treat and his Puritans sailed from Connecticut to Newark, New Jersey. Treat and Lt. Samuel Swaine began negotiating with the natives to purchase land and established a settlement in Newark. Documents dating from 1667 and 1668 show that Treat and his team were successful in purchasing a very large area of land that included South Orange. In fact, South Orange Avenue was one of the main trails upon which Native Americans traveled from what is now known as the Hudson River to the first mountain range west of the Atlantic, the Watchung Mountains.

By the time of the American Revolution in 1776, the area now known as South Orange was home to a few farmhouses, a small stone schoolhouse, a blacksmith shop, a gristmill, a general store, and a tavern. The growing population wanted a name for the community. Several names were proposed, including Orange-field. The name Orange-field was favored because it suggested that the area was both mountain and valley. It was then suggested that the word "Dale" be used with "Orange," making the name Orange Dale. That name was approved, and in 1782, a public meeting at the Presbytery Orange Dale was noted as a meeting site. On May 24, 1783, a notice advertising the availability of classrooms in Orange Dale was posted and signed by Jededia Chapman.

The first record of the name "South Orange" is in 1798, eight years before it separated from Newark and became an independent township. The separation became official on May 9, 1806, at a meeting at Samuel Munn's home in Orange. Boundary lines were established at this meeting, and *Gordon's Gazetteer* (published around 1830) described South Orange as "A village of the same township lies on the turnpike from Newark to Morristown, 5 miles west of the first; it contains about 30 dwellings, a tavern and a store, a paper mill and Presbyterian church; the lands around it are rich and well farmed."

Before the 1830s, the average American traveled no more than 20 miles from home in their entire lives. This fact sheds new light on the concept of "marrying the girl next door," and explains why many children of families in town married into another South Orange family.

In about 1835, the Morris and Essex Railroad proposed rail service from Newark in Essex County west to Morristown in Morris County and track began to be laid. The first section of track opened in 22 months and made it possible for trains to travel between Newark and Orange. Later that year, track was laid further west and trains began to serve South Orange. Rail transportation made it possible for wealthy New York City businessmen to move their families during the summer months from congested, hot, and dirty urban areas to the cool mountain air of South Orange. At that time, South Orange was known as "Little Switzerland" and the "Switzerland of America," for its healthful climate that combined mountain air with an "ocean breeze."

Mountain Station was built to accommodate both Montrose Park residents and visitors to Mountain House Spa, which began operating in 1830. New York City doctors frequently suggested that their patients try the "mountain air" as a cure for their pulmonary ailments, and South Orange's Mountain House Spa was an ideal location for guests to enjoy a recuperative summer. The spa had 150 rooms and was supervised by two physicians, Dr. O. W. May and Dr. O. H. Wellington.

Typically, drivers from the Eclipse Stage Line collected spa guests and their very large trunks at Mountain Station and transported them in horse-drawn coaches that traveled west on Mountain House Road, north along Ridgewood Avenue, and then west on what is now known as Glenside Avenue, to the end of the road. At that point, their passengers disembarked and while the coachmen unloaded trunks, the guests prepared for a luxurious stay at the Mountain House Spa.

A village charter was created on March 25, 1869, when the state legislature adopted an act that incorporated the Village of South Orange, located in the county of Essex. The 150-acre area known as Montrose Park, which was being developed as a separate community, was annexed to the Village of South Orange on February 10, 1891.

One

THE VILLAGE
BEGINS TO DEVELOP
1860–1879

In 1836, the Morris and Essex Railroad made travel possible between South Orange, Hoboken, and New York City. The fare from Newark to South Orange was about 12¢. In 1860, Seton Hall College moved from Madison to the Elphinstone property where it built the school. It was incorporated by the State of New Jersey in 1861, and in 1864, Seton Hall College adopted a corporate seal. Despite lean years during the Civil War, major fires, and several setbacks, the college continued to expand. By 1872, 500 new freshmen were on campus. Poor economic conditions in the late 1870s prompted Seton Hall to lower tuition from $450 to $380 per year.

John Gorham Vose and Henry A. Page began developing a 150-acre area known as Montrose Park in 1867, and they were joined in 1891 by Thomas Kingman. Mountain train station was built to serve Montrose Park, and today it still transports passengers to New York City via Hoboken. The concentration of large historical revival homes makes Montrose Park significant as a local, state, and national historic district.

An 1872 advertisement in the *South Orange Bulletin* promoted homes for sums ranging from $4,000 to $9,000, and suggested that it was a "healthful place to live." In 1879, telephone service arrived in South Orange. Five years later, there were only 18 subscribers in town.

The population in 1870 was estimated to be 1,800. Between 1869 and 1880, village presidents included Leonce L. Coudert, George B. Turrell (two separate terms), Thomas Fenner, F. L. B. Mayhew, Daniel T. Clark, William A. Brewer Jr. (two separate terms), and Edward Self.

Headlines included news about the Civil War (1861–1865) which took 500,000 American lives. Six days after the Civil War ended, President Lincoln was assassinated at Ford's Theater. The United States purchased Alaska from Russia, and 48 years before women won the right to vote, Susan B. Anthony (and 27 other women) were arrested for voting in a presidential election. "Come here, Watson, I want you" were the first words spoken into a receiver connected to a transmitter that Alexander Graham Bell designed as a telephone. Native Americans fought and won the Battle of Little Big Horn. It was their last major victory.

Inventions included margarine, the washing machine, the Edison microphone, phonograph and electric lamp, and the Remington typewriter.

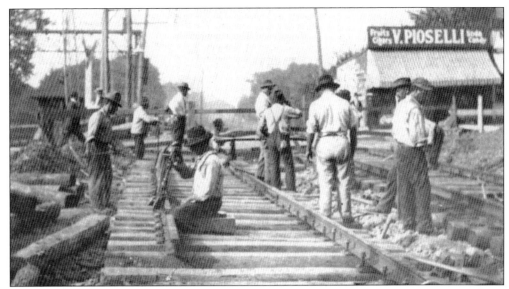

In the early 1830s, temporary tracks were laid in South Orange. In this photograph, workers have reached South Orange Avenue. The village's 100th anniversary supplement to the *News-Record* (1969) reports that "Commuters bound for New York had two hours to read their newspapers en route. Livestock from nearby farms was unloaded at South Orange, and it was commonplace to see pigs or a large flock of sheep being driven across the muddy railroad plaza." (Courtesy Martha Riker Trundle.)

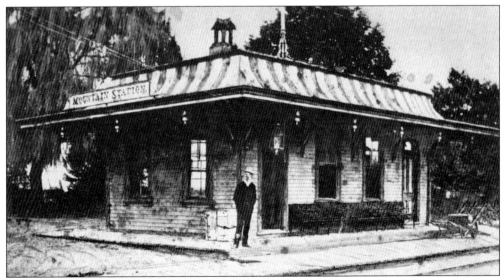

This early photograph of Mountain Station shows a style of architecture that did not match other Morris and Essex stations; this building is much less refined than other stations along the rail line. The wood-framed station house was originally named Montrose for the neighborhood it served. (Courtesy *The Delaware, Lackawanna & Western Railroad in the Nineteenth Century, 1828–1899*.)

Morris & Essex Rail Road Company.

REPORT OF TICKETS SOLD at *So. Orange* STATION.

Thanksgiving Nov 27th 1862

WHOLE TICKETS					STATIONS.	HALF TICKETS.					REMARKS
Com'cing No.	Closing No.	No. Sold.	Price.	AMOUNT.		Com'cing No.	Closing No.	No. Sold.	Price.	AMOUNT.	
6173	6182	9	47	4 29	JERSEY CITY,	398					
7448	7460	12	43	5 16	do. (accom.)	455					
					do. (Ex. ticket,)						
2737					NEWARK,	121					
6376	6386	10	18	1 80	do. (accom.)	418	419	1	9	09	
8456	8462	6	30	1 80	do. (Ex. ticket,)						
4191	4192	1	13	13	ORANGE,	175					
					do. (accom.)						
					do. (Ex. ticket,)						
					SOUTH ORANGE,						
					do. (accom.)						
7					STONE HOUSE,						
874					MILLBURN,	16					
					do. (accom.)						
211	212	1	30	30	SUMMIT,						
97					CHATHAM,						
387					MADISON,						
648					MORRISTOWN,						
27					MORRIS PLAINS,						
53					DENVILLE,						
24					ROCKAWAY,						
116					DOVER,						
28					DRAKESVILLE,						
22					STANHOPE,						
12					WATERLOO,						
106					HACKETTSTOWN,						
46					ANDOVER,						
54					NEWTON,						
TOTALS,				13 42							

SUMMARY.

Total for Whole Tickets	$ 13 42
" " Half "	$ 09
Extras, {	$
	$
Total amount of Sales,	$ 13.51

J. W. Condit recorded ticket sales in a large leather binder that was dated from July 2, 1862, to July 31, 1863. On Thanksgiving Day, November 27, 1862, thirty-six "whole tickets" and one "half tickets" were sold to passengers who boarded the train from points west of Jersey City and Newark. Ticket sales for the day totaled $13.51. (Courtesy Nancy Janow.)

11

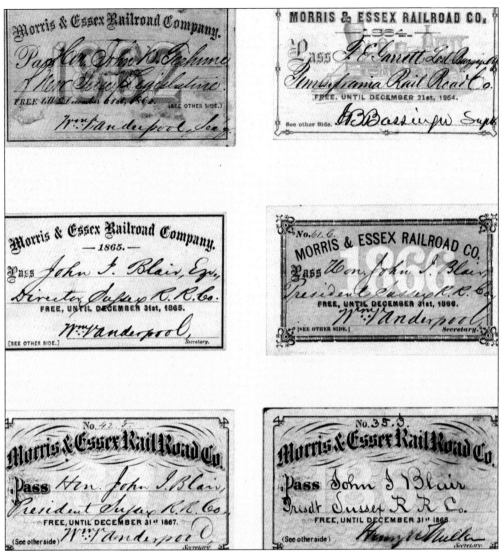

The passenger count taken in 1852, which excluded commuters, reveals that 7,371.5 passengers took the train. The very next year, in 1853, that number jumped to 8,833.5, which illustrates the growth in popularity South Orange gained in just one year. Railroad passes for about 30 years, between the 1860s and the 1890s, were colorful and highly decorated. These representative passes are in hues of yellow, green, and blue. (Courtesy *The Delaware, Lackawanna & Western Railroad in the Nineteenth Century 1828–1899*.)

Students sit in front of the Columbian School wearing knickers, high button shoes, and fashionably correct very large hair bows. The 45-foot-by-30-foot school was located on Academy Street, and although it was a two-story building, classrooms only occupied the first floor. The quarterly price per student of $1.75 covered spelling, reading, and writing. If a student wanted to learn arithmetic, parents were asked to pay another 25¢. The cost for firewood was shared equally. By 1827, a male teacher's salary for six months was $75; his female assistant was paid $48. Grading of classes began in 1867, and tuition became free in 1870. This building was used until 1889. (Courtesy Columbia High School.)

Around 1861, Seton Hall College built Stafford Hall, one of the earliest dormitories. A photograph of the dormitory is featured on this postcard. The college was principally a commuter school, but students began to live on campus around 1861. During the late-19th and early-20th centuries, Stafford Hall served as space for both dormitories and college administrative offices. This is a view of the building before the fire of 1909, which destroyed part of the edifice. (Courtesy Amy Dahn.)

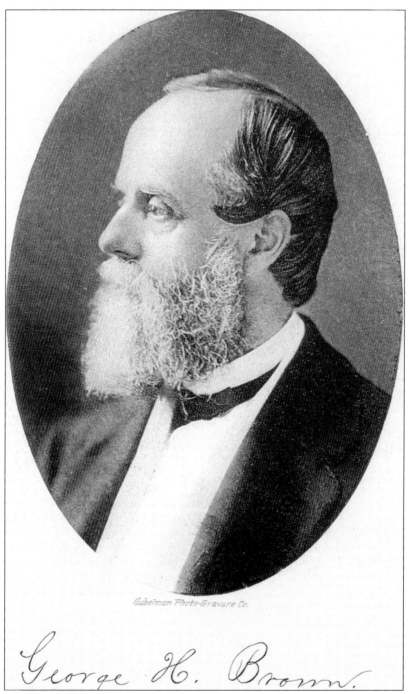

Gubelman Photo-Gravure Co.

George H. Brown.

Although George H. Brown led a relatively humble existence in South Orange as a bookkeeper (he was said to be "an expert in that line"), George was the son of David Brown, one of the most prominent families in Newark during the late 1800s. George's brother, Obediah Bruen Brown, was chief of the United States Post Office department and "a prominent and wealthy citizen of Washington, D.C. and is said to have entertained all the presidents of his time in his own home." (Courtesy Amy Dahn.)

In 1859, George H. Brown and his wife Amanda (the daughter of John Tillou) lived at this home on Scotland Road. *The Biographical and Genealogical History of the City of Newark and Essex County* describes the Browns as having "one of the pleasant homes of South Orange, in which are several pieces of furniture that have been handed down from generation to generation. . . . Their home is the abode of hospitality and its doors are ever open for the reception of their many friends." Amanda Brown is on the snowy center lawn, and George Brown is peeking in at the bottom left corner of this photograph. (Courtesy Amy Dahn.)

UNITED STATES INTERNAL REVENUE.

5 District, State of _New Jersey_

Div. No. _4_ _____ _____ , 186_3_ .

Collector's Office, _____

Mr. _Sarah Salmon_ } To U. S. Internal Revenue, Dr.

So. Orange } D. M. Wilson , Collector.

	RATE.	ABSTRACT NO.	AMOUNT TAX.
Tax on Income for the year 1864, viz:			
_Income not exceeding $5,000: Amount, $_____ at 5 per cent_			
" exceeding 5,000: " $_____ " 70 " "			
Total . . .			
Tax withheld . . .			
Tax on the following articles, for the year ending May 1, 1866 :			
Billiard Tables, kept for private use	$10 each.	261	
Carriages, valuation over $50 and not over $100	1 "	262	
" " " 100 " " 200	2 "	263	
" " " 200 " " 300	3 "	264	
" " " 300 " " 500	6 "	265	
" " " 500	10 "	266	
Pianofortes, &c., valuation over $100 and not over $200 . .	2 "	267	
" " " 200 " " 400 . .	4 "	268	
" " " 400	6 "	269	
Gold Plate, kept for use oz.	50c. per oz.	270	
Silver Plate, " " " oz.	5c. " "	271	
Gold Watches, kept for use, valuation not over $100	$1 each.	272	
" " " " " " over 100	2 "	273	
Yachts, _____			
		Amount of Tax $	1.00

Received Payment.

Collector.

In 1862, IRS collector D. M. Wilson was doing his best to track down every dollar. Wilson represented the Second District of New Jersey when he assessed Sarah Salmon just $1 for her gold watch that was valued under $100. (Courtesy South Orange Village Hall.)

Two

Electricity, Telephones, and a Fire Department
1880–1899

In 1880, *Moby Dick* author Herman Melville's youngest daughter, Frances (Fanny) Melville Thomas (1855–1938), lived at 63 Montrose Avenue, between Vose Avenue and Scotland Road. Frances's father lived in New York City and frequently boarded the train to Mountain Station. From there, Herman walked for about five minutes to the large house where Frances lived with her husband and four daughters. As a child, Francis served as a copyist for her father and proofed much of his material. As an adult, Frances resented her father and eventually asked that his name not be mentioned in her presence.

Electricity arrived in 1888; people were unsure about its dependability, so it was not uncommon for residents to adopt electricity and keep their gas-powered fixtures. Today South Orange is one of just two communities in the state that has gas-powered streetlamps. The gas lamps were originally fueled by sperm whale oil, but when public utilities became available, the lamps were converted to natural gas. The gas lamps are rated at 150 candle power.

In 1891, a volunteer fire department was established. Before then, the only way to put out a fire was by quickly establishing a bucket brigade. Open-flame gas lanterns in every home and building in town and faulty fireplace chimneys were common causes of household fires.

The first fire equipment featured hand-drawn hose reels and a hand-drawn hook and ladder. When the bell sounded, horse-drawn hose carts left the bays at village hall (the doors opened onto South Orange Avenue) and sped to the location of the fire. Later horses pulled the hose carts. When the horses arrived at the fire, the first chore was to disconnect them from the carts to remove them from danger, and walk them to help them cool down. Often a young boy would offer to handle the horses while the fireman tended to the blaze, and he was frequently rewarded with a penny!

The 1880 population in the village was estimated to be 2,178, and in 1890, 3,106. Village presidents were William A. Brewer Jr., William L. Cortelyou, Carlisle Norwood Jr., Edwin H. Mead, Edward Self, Edward F. Church, Harmon H. Hart, Eugene V. Connett, and Philip H. Cambell.

Headlines included news that Clara Barton established the American Red Cross, the Brooklyn Bridge opened, France presented the Statue of Liberty to the United States of America, the Eiffel Tower was completed, and the first modern Olympic Games were held in Athens.

Inventions included the first coated photographic paper (Eastman), the pneumatic tire (Dunlop), the first box camera and celluloid film, the electric oven, the Zeppelin airship, the zipper, the paper clip, aspirin, and the safety razor. The Curies discovered radium.

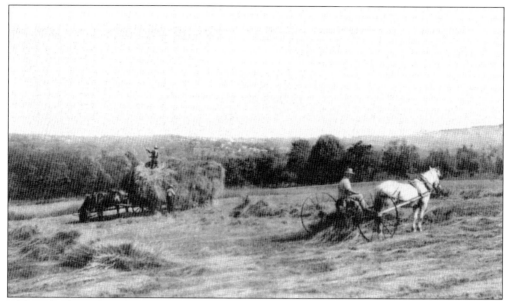

Although the village population was growing and substantial homes were being built in neighborhoods that took advantage of convenient transportation, much of South Orange was still farmland. This early-1880s photograph shows a harvest in progress when farmhands and horses did the work. (Courtesy South Orange Public Library.)

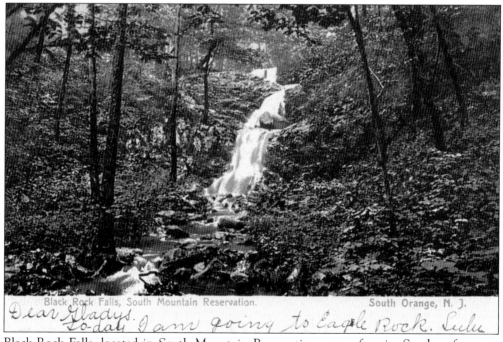

Black Rock Falls, located in South Mountain Reservation, was a favorite Sunday afternoon destination for South Orange residents who frequently took long walks back to nature. This vintage postcard left space for a message on the front of the card because the back was strictly for the address and a postage stamp. On this card, Lulu writes, "Dear Gladys. Today I am going to Eagle Rock. Lulu." (Courtesy Amy Dahn.)

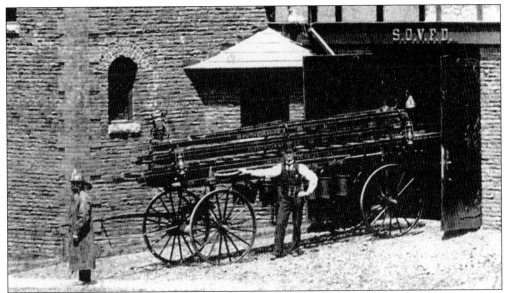

Volunteer fireman William Decker of Ladder Company No. 1 stands in front of the first hand-drawn ladder truck. Several leather water buckets hang below the ladder truck, and gas lanterns hang at the side of the ladders. Firemen were originally scheduled to be on duty for nine consecutive days with relief breaks only allowed for meals. (Courtesy Lt. Anthony Vecchio.)

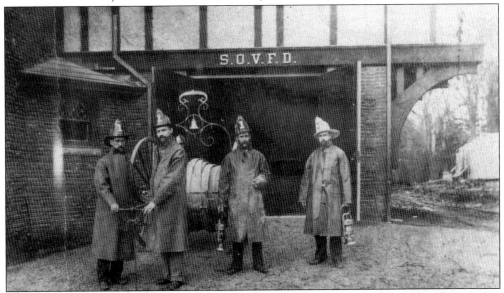

Four men from Hose Company No. 1 pose in front of open doors to the second fire house. This c. 1895 photograph was taken prior to the addition into the building, which made room for the third fire company. In this image, two volunteer firemen are carrying lanterns and two are holding the hand-pulled hose cart. When responding to a fire, 15 men ran to the site of the fire while pulling the hose cart. Hose Company No. 1 was established on February 2, 1891. Dietrich's livery stable, located on Vose Avenue, was considered the first firehouse because the fire horses were kept there. Dietrich was paid $5 a month to house the horses. Volunteer firemen in Hose Company No. 1 included John W. Stieve, Charles Galbraith, and William J. N. Carter. (Courtesy Lt. Anthony Vecchio.)

Built in 1895, this rare photograph of village hall, located at the corner of South Orange Avenue and Scotland Road, was taken at 11:06 a.m. and shows the building before any additions were made. The half-timber Tudor-style construction suggests the architecture of England and Germany during the Elizabethan period. A policeman poses with a ladder truck. In 1891, there were three divisions of the fire department: Hose Company No. 1, Hose Company No. 2, and Ladder Company No. 1. All of the equipment was housed in this one bay. Over the doorway are the letters "S.O.V.F.D," South Orange Volunteer Fire Department. A later addition to village hall included space for Hose Company No. 2, formed on September 22, 1892. (Courtesy Lt. Anthony Vecchio.)

OFFICIAL BALLOT.

Annual Election

OF THE

South Orange Vol. Fire Department,

TUESDAY, FEB. 11, 1896.

Polls Open from 8 to 10 P. M.

CHIEF.

GEORGE E. VERSOY.. X

HARRY W. HUGHES.

FIRST ASS'T CHIEF.

HARRY J. BECKER . . X

HARRY C. BURNS

SECOND ASS'T CHIEF.

JOHN STIEVE . . . X

MICHAEL A FITZSIMMONS

PRESIDENT.

HARMON H. HART . . X

CHARLES J. BARRETT

VICE-PRESIDENT.

WILLIAM B. NEWMAN

H. MARKTHALER . . . X

SECRETARY.

WILLIAM N. DRAKE

VALENTINE J. HILL, JR. . X

TREASURER.

CHARLES I. BECK . . . X

PHILIP DETRICH.

ROBERT LESLIE.

FINANCE COMMITTEE.

ARTHUR K. REEVE

ROBERT W. LESLIE

W. B. NEWMAN . . X

CHARLES GALBRAITH.

V. J. HILL, JR. . . X

P. J. SKEFFINGTON

The South Orange Volunteer Fire Department held an election on February 11, 1896, to elect a chief, first assistant chief, second assistant chief, president, vice president, secretary, treasurer, and committee members. Early members of the volunteer fire department not only worked without pay, but they paid dues of 25¢ each month. Volunteer firemen worked 24-hour days with one day off every 10 days. Between 1891 and 1898, the first paid fireman was Patrick McCahrey. By 1906, all firemen were paid. (Courtesy Lt. Anthony Vecchio.)

The "Children's Hour" was a Sunday school department 1887 at the Methodist Episcopal Church. Women in charge of the classrooms pose for a photograph at a special presentation on December 2, 1887. Rev. Frank S. Cookman (the minister in charge) and his sister, Mrs. Halstead, presented an award to Fannie Taft Halstead (the reverend's niece) for the best results on an examination of the XCI Psalm and the Beatitudes of Our Lord Mother V-2 verses. (Courtesy Seton Hall University Archives and Special Collections Center.)

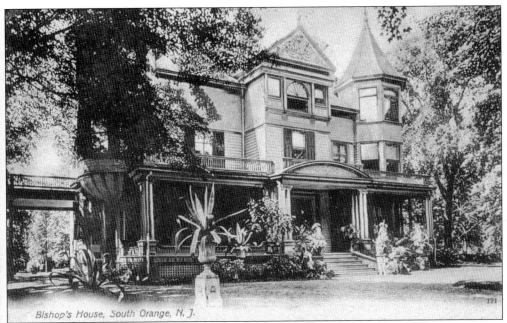

Bishop's House, South Orange, N. J.

This early-1900s postcard shows the Bishop's House, which was located on the Seton Hall College campus. It was originally the Aaron B. Baldwin home and later known as the Bishop's House at Seton Hall University. Seton Hall College purchased the house on June 11, 1901, for $35,000. It served as the official residence of the head of the Catholic Diocese of Newark, and the archbishop of Newark lived here while he served as head of the diocese until it was sold sometime in the 1940s. (Courtesy Seton Hall University Archives and Special Collections Center.)

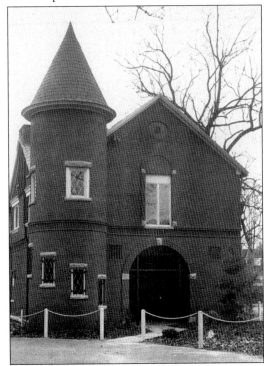

The former carriage house to the Bishop's House (no longer standing) is now the home to Seton Hall University's art department. The carriage house was built around 1887 and served as the home for horses and carriages for many years. (Courtesy Seton Hall University Archives and Special Collections Center.)

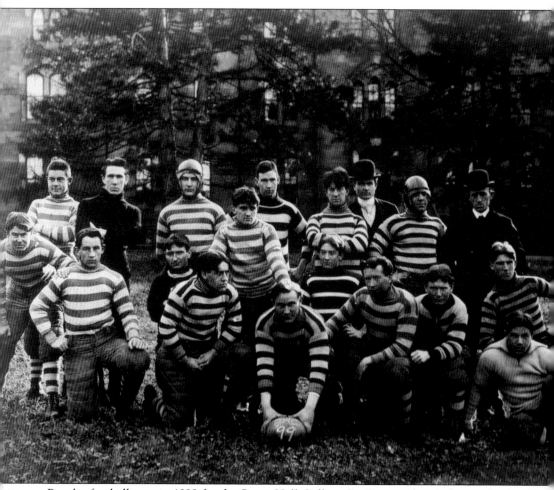

Popular football gear in 1899 for the Seton Hall College St. Georges featured striped sweaters, matching striped knee socks, padded knickers, and leather helmets with chin straps. The St. Georges are wearing their game faces, and the team coaches are wearing dark suits and bowlers. This photograph was taken on the grounds of Seton Hall College. (Courtesy Seton Hall University Archives and Special Collections Center.)

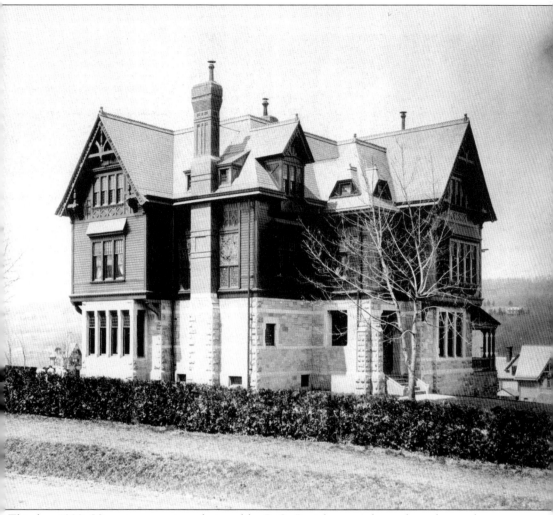

This late-1880s Victorian mansion, designed by P. G. Boticher, was located on the southwest corner of Montrose Avenue and Scotland Road. It was built to take advantage of the expansive view to the rural west. The house featured a massive stone first story and stick-style wood detailing above, as well as stained-and-leaded-glass windows throughout. Marylawn of the Oranges, a private girls' school in the early 1940s, purchased this property from the Gilligan family. The house was demolished and replaced by the school. (Courtesy private collection.)

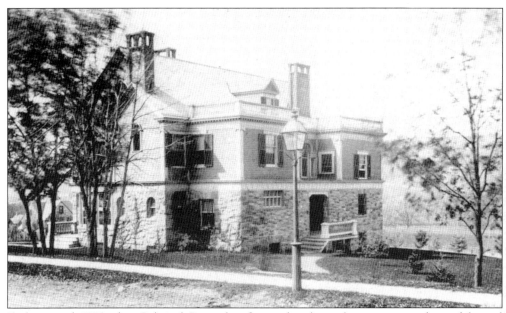

Built around 1880, this Colonial Revival–influenced, eclectic brownstone and wood-framed home was owned by B. B. Schneider in 1890. The home is set perpendicular to Scotland Road on an estate setting at the corner of Raymond Avenue. By 1911, it was owned by William S. Rodie and his wife, Marion S. Rodie. Marion was very active in town with the Women's Christian Temperance Union (WCTU), and she frequently participated in marches on foot or in decorated wagons. (Courtesy South Orange Public Library.)

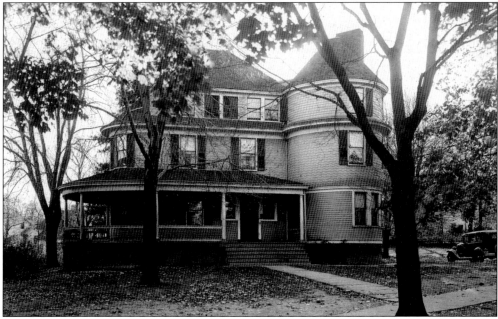

Built around 1892, this beautiful Queen Anne Victorian was situated on a track of land developed by the West Montrose Realty company. The home's original address would have been West Montrose Avenue, at the intersection of Lester Place. Today the address of this home is 356 Melrose Place. (Courtesy Roy Scott.)

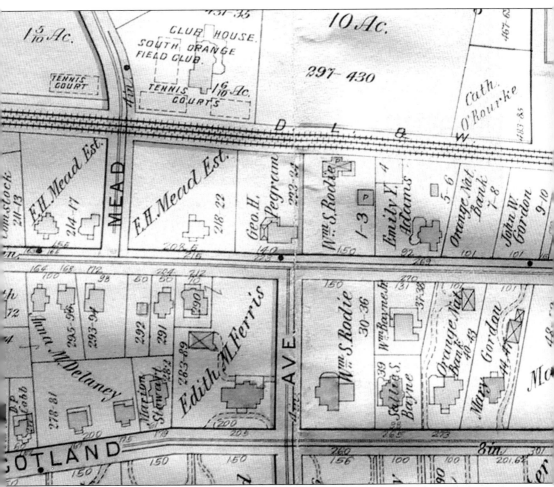

In 1904, this map of South Orange showed the E. H. Mead estate located across the elevated train tracks owned by Delaware, Lackawanna and Western Railroad from the South Orange Field Club. Edwin Mead's barn was originally used as the clubhouse. In the 1940s, village residents who took the train often referred to the line as the "Delay, Linger and Wait" railroad. (Courtesy private collection.)

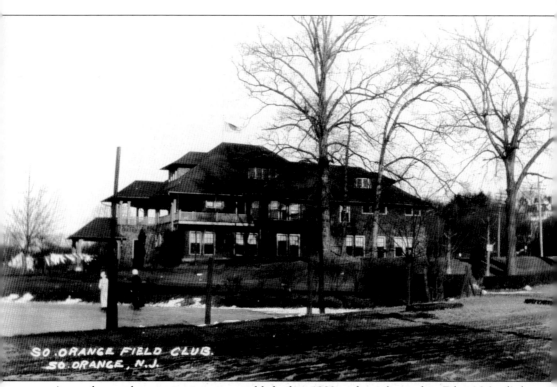

SO. ORANGE FIELD CLUB.
SO. ORANGE, N.J.

A members-only organization was established in 1889 and was located in Edwin Mead's barn. That structure burned to the ground in January 1895, and this new building replaced it and became known as the South Orange Field Club. By 1929, more sporting activities were added to the roster and the private club became a community center. In 1930, the field club became known as the Baird Center. (Courtesy Eleanor Farrell.)

EDWIN H. MEAD.

Born on March 23, 1822, in New York City, Edwin Mead held positions with a linen importer, the Pennsylvania Coal Company, and the Erie and Wyoming Valley Railway Company. He was active in the New York Chamber of Commerce and the American Geographical Society. Mead moved to South Orange in 1868 and purchased 10 acres on Ridgewood Road, where he built a "beautiful country home" named Springlawn. His influence attracted other wealthy people to the village, and he promoted several public improvements including a village charter and draining wetlands. Mead was an influential and generous member of the Meadow Land Society. He was also an original member of the South Orange Field Club, and his barn served as the original clubhouse. Mead Street is named for Edwin Henry Mead. (Courtesy Amy Dahn.)

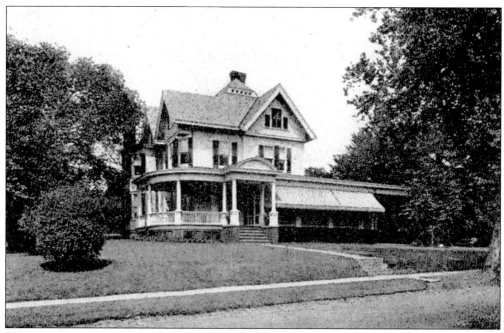

This Queen Anne home on Ralston Avenue was built around 1880. In 1890, the home was owned by H. B. Bailey, and in 1904 by Mrs. E. W. Orvis. Other residents include the Rummle family (Mr. Rummle was a professor at Seton Hall) and the Barrymore acting family, when John and Ethel were children. In 1923, it was the home of H. Wallace Smith. The garage originally held an array of carriages and ponies. In 1952, the home was purchased by Mr. and Mrs. Papp where, over the next 22 years, they raised their seven children. Mr. Papp was an executive at B. Altman's department store in Manhattan. (Courtesy South Orange Public Library.)

Electricity arrived in the village in 1888. People were not convinced that electricity was dependable. Therefore, it was common for residents to adopt electricity and keep their gas-powered fixtures; dual fuel fixtures were also commonplace. Many of the older homes in South Orange still have gas fixtures that have been converted to electrical use. (Courtesy private collection.)

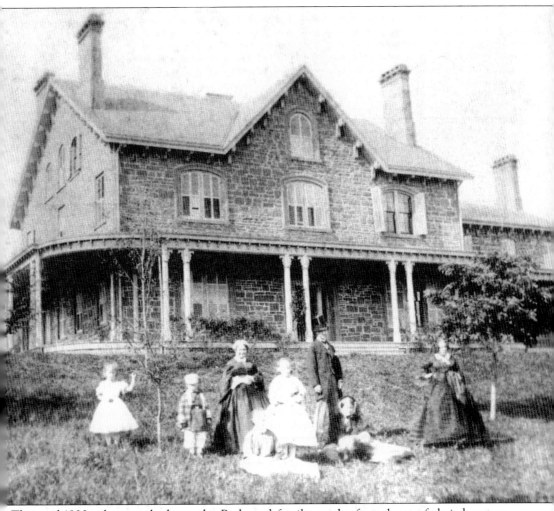

This mid-1800s photograph shows the Redmond family on the front lawn of their home at 305 North Ridgewood Road, named Hillside. William Redmond owned several acres of land in the village. Mrs. Redmond died in March 1870, and William Redmond died in 1874. However, the property remained in the family until 1916. At that same time, Orange Lawn Tennis Club was outgrowing its facilities in Montrose Park and the membership voted to purchase the Redmond property and relocate the club to North Ridgewood Road. Orange Lawn transformed the home into a clubhouse and built lawn tennis courts on the property. Eventually they added a swimming pool. (Courtesy Nancy Janow.)

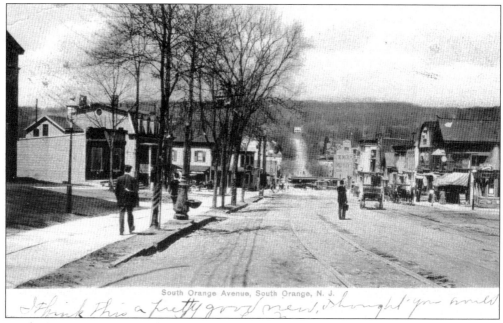

South Orange Avenue, South Orange, N. J.

South Orange Avenue, in this *c.* 1895 photograph, shows men and horse-drawn carriages walking west, just above Vose Avenue. The top level of the water fountain (shown left) caters to pedestrians who could drink from the sidewalk. The lower level bowl is used by thirsty horses. This early postcard contains a message from Nancy, who thinks this is a good view of South Orange and the rural lands west of the village.

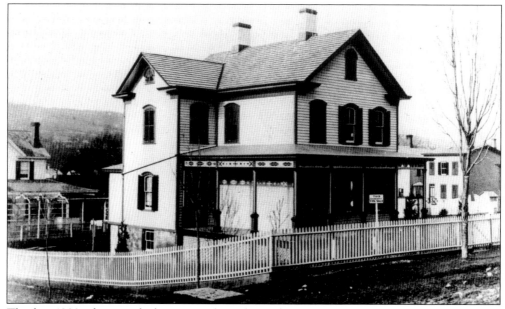

This late-1800s photograph shows a residence located on rural Scotland Road. In the front yard a very small sign reads, "This Property Is for Sale." (Courtesy South Orange Public Library.)

This c. 1900 Colonial Revival home was the Vose Avenue home of George H. (1855–1937) and Jessie Pegram. George worked at the Union Pacific Railroad where he invented the "Pegram Truss" ironwork. He later designed Union Station in St. Louis and a power plant in Ogden, Utah. George moved his family to their main residence in Manhattan in 1898 when he joined the Manhattan Elevated Railroad Company. In 1905, he became chief engineer on the IRT (Interborough Rapid Transit) Ninth Avenue subway line, the first elevated line in New York City. Jessie Pegram lived in this house until her death in 1948, and their daughter, Jean, lived there until 1972. (Courtesy South Orange Public Library.)

In the late 1800s, George W. Comstock owned several properties between Vose Avenue and Scotland Road. On April 1, 1873, George W. and Lydia Comstock of New York City sold their property lots 15 and 16 to Caroline Matilda Pemberton and John P. Pemberton. By 1892, this shingle-style home at 103 Scotland Road was built at the intersection of Comstock Place. By 1894, the home was owned by Jennie C. Taylor, wife of Lewis P. Taylor. Lewis was the South Orange postmaster and a surveyor. (Courtesy South Orange Public Library.)

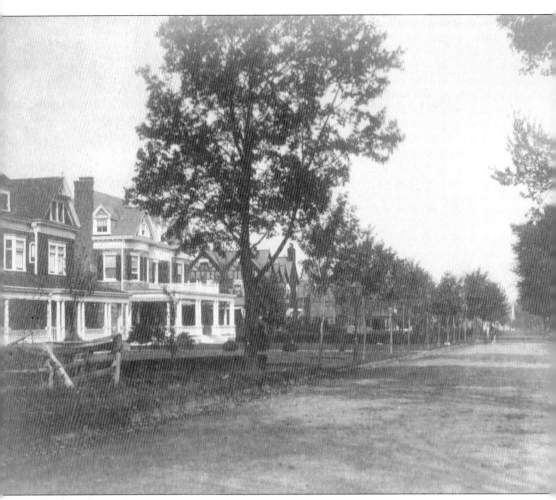

In 1899, Centre Street, as seen from South Orange Avenue, is a wide residential road with several large homes in view. The house on the far left no longer exists. The next home, at 413 Centre Street, still stands and was the home of the Herman C. Hildebrand family, owners of the Martha Washington Candy Company. Prior to the Great Depression, the Martha Washington Candy Company consisted of 29 stores, including one in South Orange.

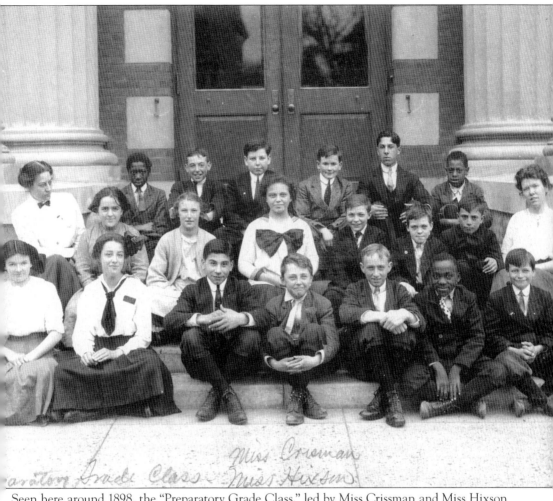

Seen here around 1898, the "Preparatory Grade Class," led by Miss Crissman and Miss Hixson poses on the front steps of the elementary school. Miss Crissman (second row, left) shoots a sour glance in the direction of a mischievous student. Several of the boys are laughing at the inside joke. (Courtesy Columbia High School.)

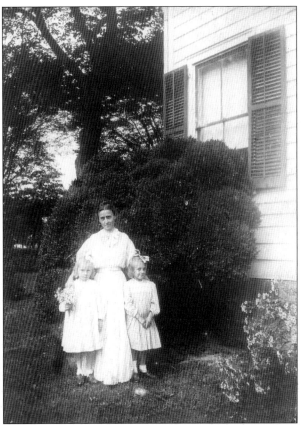

Edward Self, who served as village president from 1888 to 1889, lived on the family farm, which was located very near the Seton Hall College campus. The farm was a major source of dairy products to the college. Over the years, the residence of the Self farm was known as the house with the "white chimneys" or simply "the Self House." Today Self Place in the Montrose Park section of South Orange is named in honor of the family. Edward and Anna Self had four children: Peggy, Anna, William, and Sydney. Anna Self smiles for the camera at the corner of her farmhouse with her two daughters. (Courtesy Jacob Levine.)

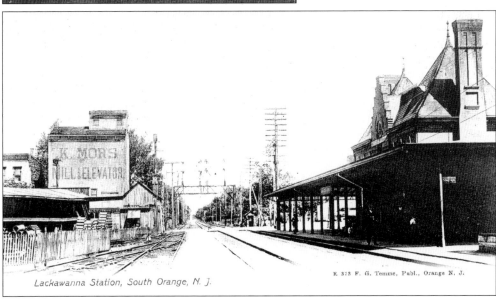

Lackawanna Station, South Orange, N. J.

E. 373 F. G. Temme, Publ., Orange N. J.

On the west side of the Lackawanna train station, seen here around 1890, K. Mor's Mill and Elevator attests to the rural nature of South Orange. Farmers brought their grain to Mor's mill to be stored in the elevator and then ground it when the grain was sold. (Courtesy Seton Hall University Archives and Special Collections Center.)

Three

THE BUZZ ABOUT SOUTH ORANGE
1900–1919

In 1900, the town brought in L. O. Howard, chief entomologist of the U.S. Agricultural Department to help eradicate the large mosquito population. Howard suggested that kerosene oil be spread on all standing pools of water, and that year the village spent $1,000 to spread kerosene on every potential mosquito breeding place. In 1903, the *New York Sun* and *Washington Post* recognized the village for its great reduction of mosquitoes and the potential spread of malaria. The mosquito commission (active into the 1920s) was so well known that author O. Henry referred to South Orange in his 1910 short story, "The City of Dreadful Night." The narrator has poor grammar and refers to a sweltering night in New York City: "The Park Commissioner and the Commissioner of Police and the Forestry Commission gets together and agrees to let the people sleep in the parks until the Weather Bureau gets the thermometer down again to a living basis. So they draws up open-air resolutions and has them O.K.'d by the Secretary of Agriculture, Mr. Comstock, and the Village Improvement Mosquito Exterminating Society of South Orange, N.J."

The 1900 population was estimated to be 4,608; ten years later, it reached 6,014. Village presidents included Ira A. Kip Jr. (two terms), Albert C. Wall, Robert S. Sinclair, Francis Speir, Roy Clarke, and Edward Duffield.

Residents were reading about the first flight of Wilbur and Orville Wright's Wright Flyer, at Kitty Hawk, North Carolina, and Madam Curie, who won the first of her two Nobel prizes for the discovery of radium. Henry Ford's first Model T Ford rolled off the assembly line, and that same year the mayor of Cincinnati told the city council that no woman is physically fit to drive a car. Cunard Lines' *Titanic* sank on April 14, 1912. Of the 2,200 passengers aboard, 1,517 died. World War I began and ended, and the 1918 influenza epidemic ravaged the world.

New inventions included Marconi's first successful transatlantic radio transmission, Geiger's counter to measure the radioactivity of Madame Curie's radium, and Einstein's theory of relativity.

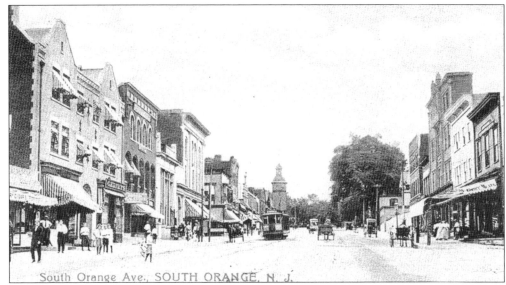

South Orange Ave., SOUTH ORANGE, N. J.

Excellent transportation in South Orange signaled an influx of residents and new houses that were commonly built within a five-minute walk to the nearest track. This early-1900s photograph shows a trolley owned by the Newark, Montrose and South Orange Horse Car Railroad Company sharing the main street with horses and carriages. The trolley company laid track on South Orange Avenue and centrally located residential streets to convey passengers between Newark and South Orange. (Courtesy Seton Hall University Special Collections and Archives Center.)

A horse waits on the corner of Sloane Street and South Orange Avenue as it is parked outside a first-floor convenience store operated by William Kehoe. In addition to sundry items, Kehoe advertises that he sells "soda." A 1911 *Atlas of the Oranges* attributes this clapboard building with a standing seam roof to H. W. and Mary Hughes. In the distance is the public school. Today this building is barely visible, ensconced within the series of buildings that stands at the corner of South Orange Avenue and the east side of Village Plaza. (Courtesy South Orange Public Library.)

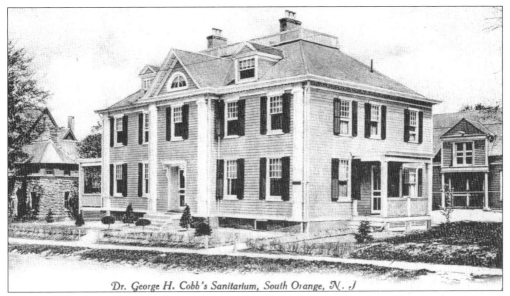

Dr. George H. Cobb's Sanitarium, South Orange, N. J

This *c.* 1906 postcard shows the residence of Dr. George Henry Cobb at 117 Irvington Avenue. Dr. Cobb (1863–1926) graduated from the College of Physicians and Surgeons of Columbia University in 1888. He was a member of several medical associations as well as the Orange Mountain Medical Society. Dr. Cobb transformed his home into a sanitarium, a medical facility (or health resort) for long-term illnesses, typically tuberculosis. Sanitariums were common in the early years of the 20th century. (Courtesy South Orange Public Library and University of Medicine and Dentistry of New Jersey Special Collections.)

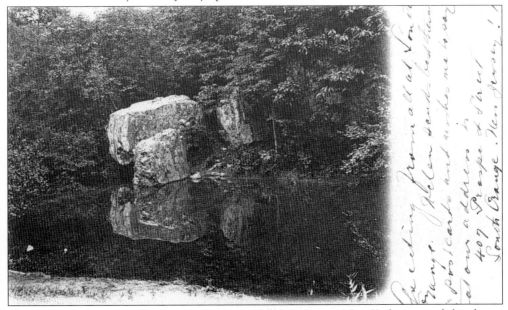

Miss Pickenbach at the Vista, Haines Falls, Catskill Mountains, New York, received this dreary postcard of Rock Hole on the Rahway River, South Orange, around 1907. The message reads, "Greetings from all at South Orange. Helen sends best regards and wishes me to say that our address is 407 Prospect Street, South Orange, NJ." (Courtesy Seton Hall University Archives and Special Collections Center.)

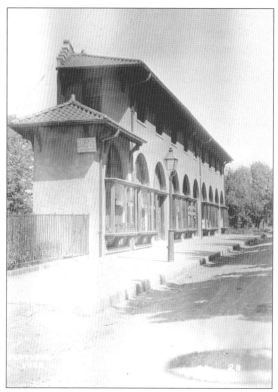

This building has a footprint designed to match the boundaries of its lot. It was nicknamed the South Orange Flatiron Building, which was designed by D. H. Burnham. The South Orange Flatiron Building, shown here around 1940, was located on Vose Avenue, near South Orange Avenue, and was owned by George W. Comstock. Over the years, it was the site of various service providers and retailers. The building was torn down in 2005 to make way for condominiums. (Courtesy South Orange Public Library.)

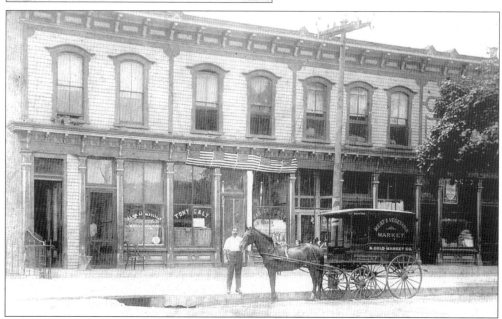

A horse-drawn delivery truck and driver from Gold's Market Company, purveyors of meat and vegetables, stand in front of several storefronts on the south side of West South Orange Avenue in 1911. The windows in the storefront, above the horse, read "Barber Shop." Alex Beatrice owned this shop, which was located at 3 West South Orange Avenue. Beatrice opened his shop in 1896. (Courtesy Debbie Adler.)

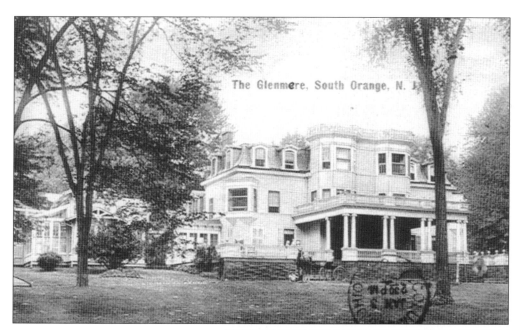

The Glenmere, South Orange, N. J.

In 1900, Glenmere (at 349 Ridgewood Road) was one of two named estates in town, the other being Hillside, the estate of the Redmond Family. Mercy and Hiram Rogers, and subsequently their son, Albert P. Rogers, lived at Glenmere. Around 1900, Albert Rogers (who became a humane activist) promoted one of the smartest horses ever known, Beautiful Jim Key. Veterinarian William Key owned, trained, and took care of Jim, who traveled around the country performing amazing acts that made both Albert and Dr. Key very wealthy. Just behind Glenmere on property owned by Harriet A. Hoskier was a quarter-mile track, an excellent length for exercising a horse such as Jim Key. *Beautiful Jim Key* was written by Mim Eichler Rivas. Modeled after the fanciful French palace at Fontainebleau, Glenmere was sometimes mistakenly called by that name. The mansion was on prime real estate, bordered by a flowing brook that ran along its one side, and was one lot away from a riding ring. (Courtesy Seton Hall University Special Collections and Archives Center.)

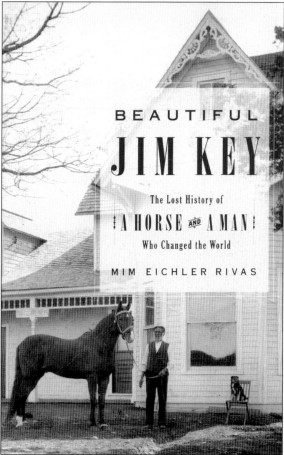

BEAUTIFUL

JIM KEY

The Lost History of

A HORSE AND A MAN

Who Changed the World

MIM EICHLER RIVAS

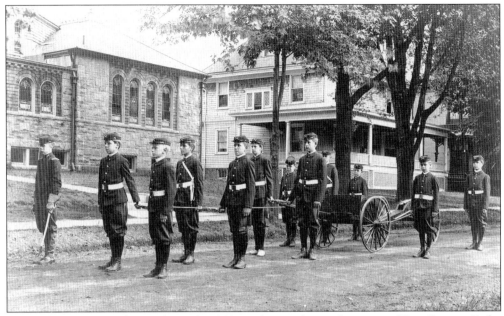

Boy Cadets were popular in the early 1900s and were the predecessors of Boy Scouts. Cadet groups targeted boys aged 14 to 17, and the program was designed to teach them survival skills, independence, and self-reliance. In this photograph, the Boy Cadets are wearing uniforms that resemble military uniforms that soldiers wore in the Civil War. (Courtesy Seton Hall University Archives and Special Collections Center.)

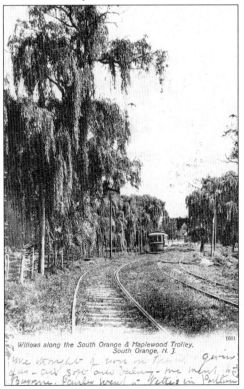

Willows along the South Orange & Maplewood Trolley, South Orange, N. J.

"Willows along the South Orange and Maplewood Trolley - South Orange, N.J." shows a 1910 view of grass growing up through the tracks and tree branches hanging down on the trolley. These trolley tracks traversed Meadowbrook Lane along the Rahway River from Orange to South Orange. The line joined the South Orange Avenue line where Meadowbrook Lane used to meet South Orange Avenue where today the Reservoir Restaurant and Pizzeria currently exists. (Courtesy Seton Hall University Archives and Special Collections Center.)

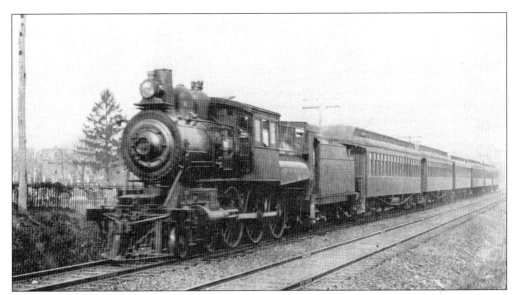

This *c.* 1909 photograph shows train No. 697, which was a six-car commuter train. Trains numbered in the 690s were all ten-wheelers. They were modernized and serviced commuter lines in South Orange and other nearby train stations for many years. (Courtesy Mark Lerner.)

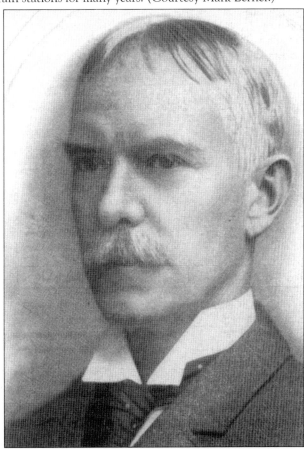

On Tuesday, February 1, 1916, Francis Speir was honored at a dinner for his service to South Orange. He served as village president from 1911 until 1915, and was also instrumental in the project that resulted in elevated railroad tracks at the South Orange train station. The public testimonial dinner honoring Speir was held inside the main waiting room at the new train station. Speir Drive, in the Newstead district of South Orange, was named for Francis Speir. (Courtesy South Orange Public Library.)

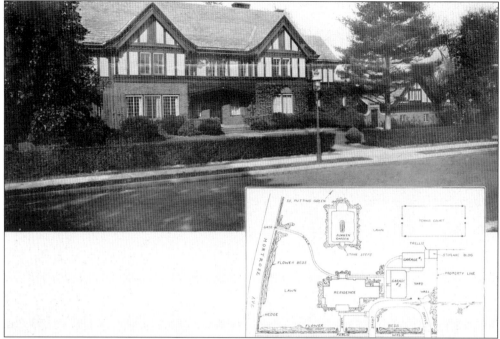

Toad Hall is a three-story, English Tudor–style residence built between 1916 and 1918 by a Mr. Webster who was in the sugar business. When Webster's sweet business went sour in 1927, he filed bankruptcy and Jay Randolph Monroe (who invented the calculator) purchased the property. He launched the Monroe Calculating Machine Company in 1912 and located his factory on Jefferson Street in Orange. Monroe remodeled Toad Hall by adding the sunroom, breakfast room, and front garage. (Courtesy John and Roseanna Zoubek.)

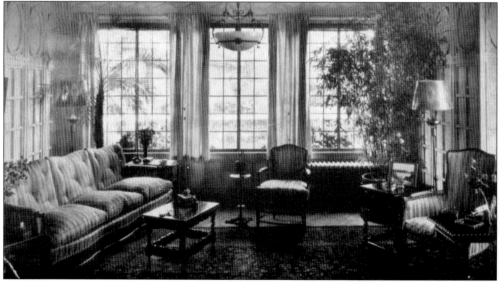

The Palm Room is decorated with wood lattice on the ceiling, which also features a decorative dentil molding. The floor is Carrara marble. The doors on the far end lead to the small brick porch. Leaded glass windows are located throughout the house. (Courtesy John and Roseanna Zoubek.)

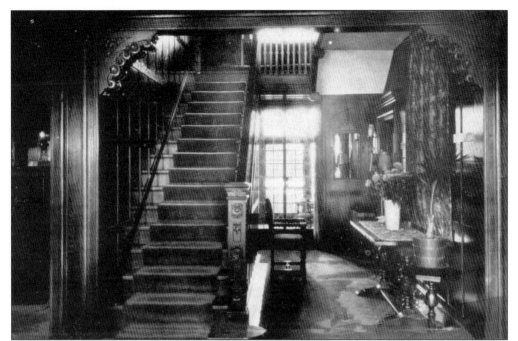

Toad Hall's entrance foyer has curved ceilings with decorative plaster molding and rich solid oak paneling and parquet floors. The staircase features a hand-carved banister. The through hall leads to a breakfast room, billiard room, and a sun room. Around 1998, the interiors for the movie *The Yards* were filmed here. *The Yards* featured an all-star cast including Faye Dunaway, James Caan, Ellyn Burstyn, Joaquin Phoenix, Mark Wahlberg, and Charlize Theron. The movie premiered in 2000. (Courtesy John and Roseanna Zoubek.)

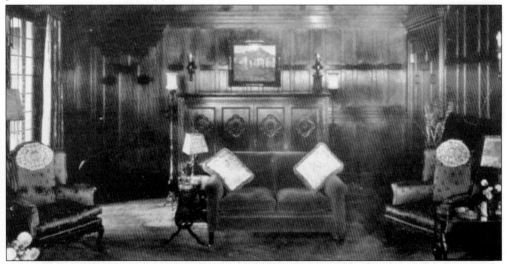

The walls at Toad Hall are completely paneled in solid oak, and the room has a decorative plaster ceiling. The fireplace mantel is from England; the sconces are Steuben Glass. The dominant feature of this room is the 55-stop Skinner organ with three ranks, which was installed by Jay Randolph Monroe. The organ plays both manually and automatically and has an echo loft in the attic. The compressor and pipes are located in the basement, and the sound comes up through grating at the far end of the room. (Courtesy John and Roseanna Zoubek.)

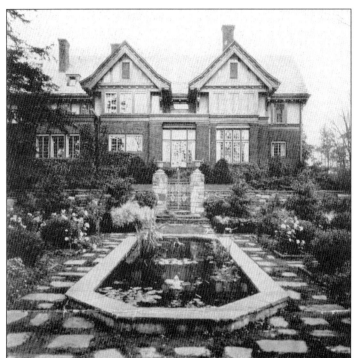

The original property for Toad Hall included all of the land from Halsey Place to Scotland Road. In addition to the formal gardens (designed by Ethelbert Furlong of Montclair) shown here, the property included a tennis court, orchard, and putting green. All but about three acres were sold, and houses were built on what are now Henderson Road and Thatcher Lane. (Courtesy Johan and Roseanna Zoubek.)

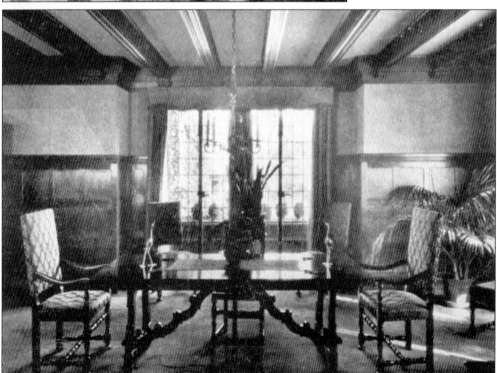

The dining room at Toad Hall features solid oak walls and hand-carved ceiling beams. Dutch tile surrounds the fireplace, and Tiffany sconces illuminate the room. (Courtesy John and Roseanna Zoubeck.)

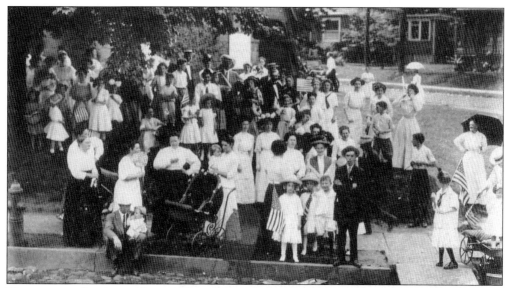

Flag-carrying families gather on the property belonging to the First Presbyterian Church of South Orange, at the intersection of South Orange Avenue and Academy Street on July 4, 1911, to celebrate Independence Day. Many of the women and children are wearing their summer whites and carrying parasols or wearing hats to stay cool in the July heat. Decorated prams and wagons are empty as parents hold their children in anticipation of the passing parade. The photographer's camera box and equipment are resting in the street. (Courtesy Montrose Park Historic District Association, gift of Brendan Nolan.)

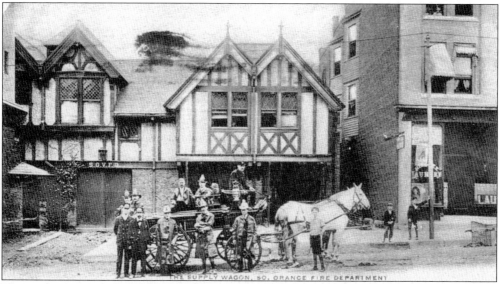

This early postcard shows the addition to village hall, built to accommodate fire equipment. Two white horses (a firefighting status symbol) stand in front of the wagon for Hose Company No. 1. Three young boys wearing knickers pose for the snapshot. To the right of the boys is the Chinese Laundry. When a veteran fire horse, named Horse Dick, was ready to retire from a life of racing to fires, the owner of the laundry shop purchased him and put the horse to work pulling his laundry wagon. It was said that even in his retirement Horse Dick still responded to the call of the firehouse bell. (Courtesy Lt. Anthony Vecchio.)

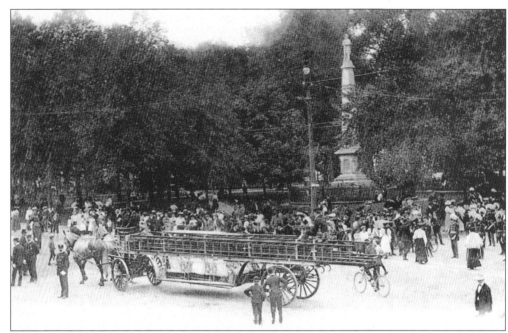

The South Orange Fire Department drove its horse-drawn tiller ladder to Morristown to participate in a parade around 1905. Look closely to see the driver perched in the front seat driving the two-horse team. In the rear of the vehicle, seated over the wheels is the "tiller man" who was responsible for operating the perpendicular steering wheel (tiller). The tiller operates the rear wheels. (Courtesy Lt. Anthony Vecchio.)

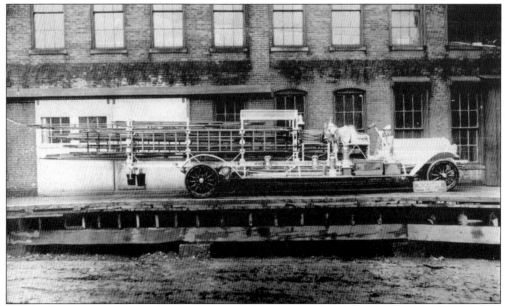

Resting on the loading dock at the Seagrave manufacturing facilities in Columbus, Ohio, is a brand new white 1913 Seagrave ladder truck, which the South Orange Village Fire Department custom ordered. A train is scheduled to pull alongside the loading dock and transport it to South Orange. (Courtesy Lt. Anthony Vecchio.)

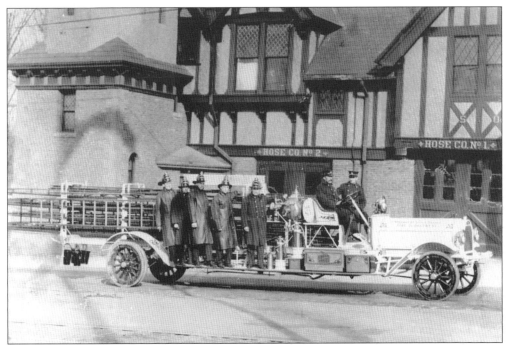

This c. 1913 photograph shows members of Hose Company No. 1. Five firemen stand on the sideboard of the new 1913 Seagrave finished in white paint, which was just received from the factory in Columbus, Ohio. Four of them are wearing heavy gear; the other three are wearing fire department–issued double-breasted wool coats. Sitting at the wheel is Charles Searles. Fire Chief William Ash is standing on the runner, on the far side. (Courtesy Lt. Anthony Vecchio.)

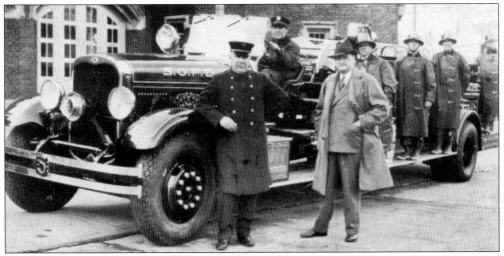

Fire Chief John C. Loughran stands with the director of public safety, Eugene F. Krauelter, in front of a 1913 Seagrave fire truck. Sitting in the driver's seat is Andrew C. Ippolito, and standing on the sideboard are, from front to back, Patsy Paul Ippolito, Gaetano Mercadante, and Charles Searles Jr. Around 1929, Patsy Paul Ippolito played semiprofessional baseball for South Orange and was known for his mighty swing. On October 29, 1929, Ippolito had to work at the firehouse during the Babe Ruth and Lou Gherig exhibition game held in South Orange. Rumor has it that missing the game nearly killed Ippolito! (Courtesy Lt. Anthony Vecchio.)

THE COLUMBIAN

The cover of this 1917 issue of *The Columbian* (Columbia High School's student newspaper), displays a drawing of a graduating senior running from the steps leaving the hallowed halls of high school, diploma in hand, to begin the next adventure. (Courtesy Alex Somers, Columbia High School.)

JUNE, 1917

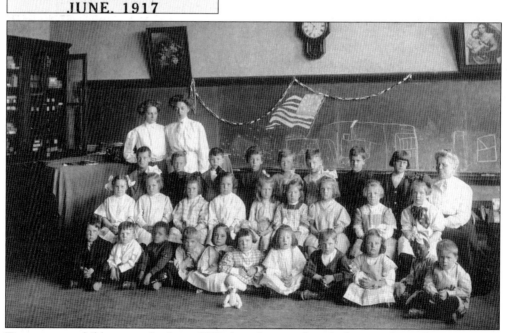

Twenty-seven children pose for this *c.* 1903 class photograph with three teachers who are wearing similar high-neck lace blouses. In this photograph, the blackboard features an early American flag, flying backward. The baby grand piano is covered with a large protective cloth, and a small bear with jointed arms and legs sits front and center. (Courtesy Columbia High School.)

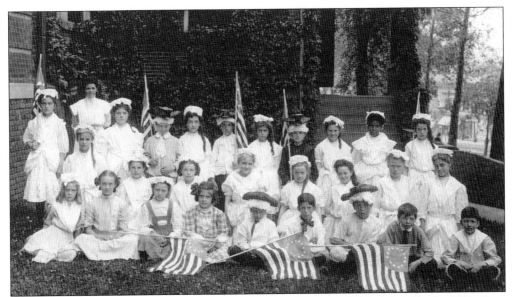

Elementary students, around 1915, wear costumes representing 1776 and carry the Betsy Ross flag. In May 1776, three members of the Congressional Committee—George Washington, Robert Morris, and George Ross (Betsy's late husband's uncle) called upon Betsy Ross at her upholstery shop and asked her to sew the first flag. She finished the flag either in late May or early June 1776, in time for the signing of the Declaration of Independence. That document was read aloud for the first time at Independence Hall. Amid celebration, the Liberty Bell tolled, heralding the birth of a new nation. (Courtesy Columbia High School.)

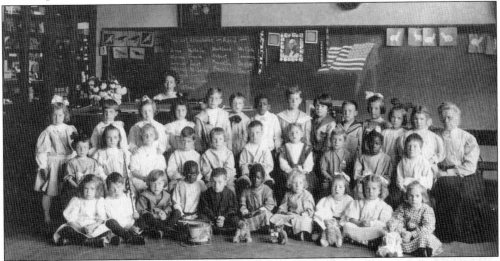

This *c.* 1903 elementary school photograph features 33 children in a music class. The music teacher is seated in the back, left, at the piano, and a classroom teacher is seated on the right. The children have placed in front of them a drum with sticks, three jointed teddy bears, and a doll that can sit and stand. Jointed bears were very new to the marketplace. The first company to produce jointed stuffed bears was Steiff Company of Giengen, Germany. Between the years of 1902 and 1903, they launched bears with limbs that could move and allow the bears to stand upright and hold up their front legs. Before jointed limbs, stuffed bears were made to stand on all four legs. (Courtesy Columbia High School.)

ALUMNI NOTES

South Orange bows in admiration to the Alumni! "A Pair of Sixes," the play given by the Alumni for the benefit of the Red Cross, was indeed a great success. Although all did credit to themselves as Alumni of Columbia High, Evelyn Martin and Elliot Bergen deserve special comment. By selling candy at this play the High School girls gained ten dollars for the junior unit of the Red Cross.

Harold Lonsdale, '16, was home from Wesleyan for a few days, as his eyes prevented his doing any college work.

Mabel Poulson, '16, is now doing library work in Asbury Park.

Arthur Lea Mond, '15, is a member of the varsity baseball team of Notre Dame University, where he is now a Sophomore.

Elva Cooper, '15, has won a scholarship for next year at the New York School of Fine and Applied Arts, which entitles her to next year's tuition. Also, she is to become a member of the faculty.

Elmer Van Tubergen, '12, is now in the training camp at Fort Meyer, Virginia.

Willard Oberrender, '15, is awaiting orders to go to France with the Motor Transportation Corps.

Anita Yereance, '13, has announced her engagement to Kenneth Girdwood of West Orange.

Callene Thomas, '14, has returned to the New Haven Normal School of Gymnastics after a serious illness. She expects to graduate this year.

Elliot Bergen, '12, has joined the Naval Reserve.

Josephine Tucker, '15, and Louise Collyer, '15, are at Sargent Camp, Peterboro, New Hampshire.

Willard Vanderhoof, ex-'18, has been made a sergeant in the Engineering Corps, N. J. N. G.

SCHOOL NEWS

We all regret very much that Mrs. Fish has left us. However, we have been somewhat consoled by many interesting Senior topics, and by Mr. Freeman's continued illustrated lecture on a trip to Europe.

The Euterpean Society and the Glee Club have been given up for the present, owing to the absence of director.

On Saturday evening, April 28, the Sophomore class gave a dance in honor of the Seniors. The dancers were much amused by the scenes from the Senior plays, acted by Sophomores. Everybody had a splendid time.

On May 7 a meeting of the Columbian subscribers was held in the auditorium, at which a constitution was adopted. On the following Friday, May 11, a second meeting was held in the library for the purpose of nominating the new Columbian board. The names were passed on by the faculty and voted upon in the following week.

A meeting was held on May 23 of the old and new Columbian boards. The old board expressed their desire to help the new one in any way possible. The publication was officially turned over to the new board at this meeting.

A Parnassian meeting was held on Tuesday, May 15, at which officers were nominated for next year. During this month the following were elected to membership: Wynona Coykendall, Louise Pitman, Laura Miller, Dorothy Gwynne and Elsie Trauter.

Mr. Freeman recently read to the school a letter from Miss MacGrath, telling about the sick soldiers in Virginia. She said that the money sent her by the school had been of the greatest

Inside, the *Columbian* includes news of previous graduates and a report that alumni performed a play, "A pair of Sixes," to help benefit the Red Cross. The high school girls capitalized on that event by selling candy at the play and earned $10 for the junior unit of the Red Cross. (Courtesy Alex Somers.)

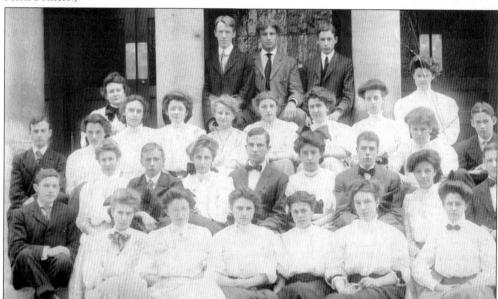

In the early years of the 20th century, it was traditional for the Columbia High School senior classes to arrange themselves on the steps of the Methodist Church located at 150 South Orange Avenue. This 1907 senior class is no exception. Thirty students are shown taking advantage of the grand columns as they pose for their graduation photograph. (Courtesy Nancy Janow.)

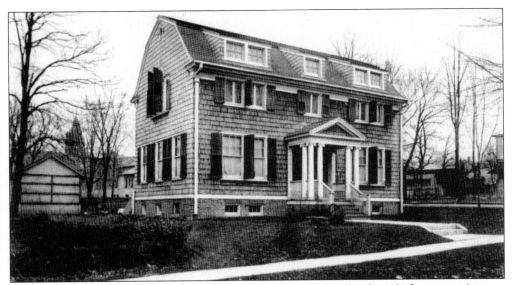

Between 1905 and 1915, Harriet M. Spining operated a private school at 121 Irvington Avenue, between Academy and Prospect Streets. In 1911, this home was listed as the home of Rev. George L. Spinning, who is listed as owner of both addresses 121 and 123. (Courtesy Nancy Janow.)

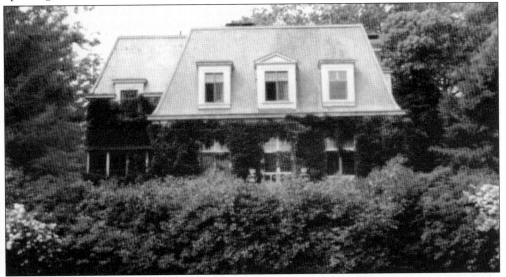

Linden Lawn is named for the 100-year-old Linden tree that occupies part of the front yard at 351 North Ridgewood Road, which was built in 1903 by architect Edward T. Gooch and his wife, Josephine. They purchased the property on December 11, 1896, from Anna S. and Thomas S. Kingman. A property restriction stated that any home built on that land had to be valued at a minimum of $10,000, and the imposing French Chateau–style home with a slate Mansard roof and a carriage house on the four-acre plot met those standards. Shown here in 1966 with large shrubbery and years of climbing ivy that covers the brick facade, the house is more than 242 feet from the street and features a private driveway from Ridgewood Road. The 12-room home includes three master bedrooms, three full and two half baths for the family, and servants' quarters on the third floor. Two large rooms with black walnut–paneled walls, beamed ceilings, hand-carved trim, and three marble fireplaces dominate the first floor. (Courtesy Sam Joseph and Dan Arrighi.)

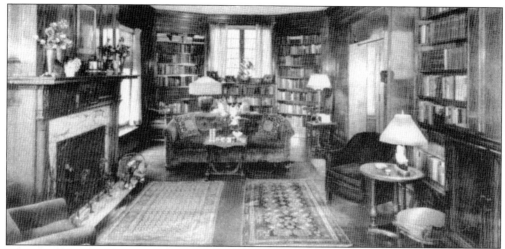

The scent of spring blossoms on Linden trees reminded the Gooches of their home on Bryanston Square in London, so they planted a small Linden tree in their front yard and promptly christened the home Linden Lawn. On March 1, 1918, the Gooch family sold the home to Mary MacMahon for $18,500 and returned to their native England. MacMahon built a small Catholic boarding school for young girls on the property. This interior photograph shows the 35-by-18-foot library of Linden Lawn as it was decorated in 1966. Black walnut–paneled walls, book-lined shelves, hardwood floors, comfortable furnishings, and a marble fireplace set the tone for an afternoon of reading and relaxing. Two sets of French doors lead to a slate patio. (Courtesy Sam Joseph and Dan Arrighi.)

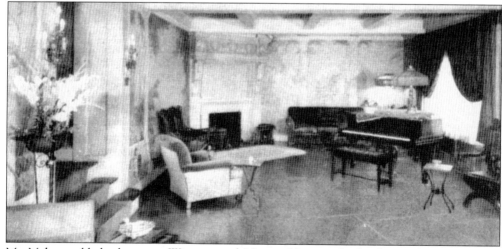

MacMahon sold the home to Winston and Miriam Uppercu Paul, who used it as a private residence. A divorced Miriam Uppercu Paul sold the house on September 30, 1953, to Burdette and Betty Bostwick, who then sold it on May 1, 1967, to Abner and Norma M. Benisch. Scenic painted walls, a tile floor, fireplace, and bubbling fountain welcomed visitors to Linden Lawn in 1903. Carriages pulled up to this lower-level entrance where guests entered the French living room through wide doors. There they were assisted in removing coats and furs; a powder room was available, and in winter they could warm themselves by the fireplace. This 1966 photograph shows the room furnished with large chairs, sofas, and a grand piano. The home originally included an Otis elevator, which transported visitors from the French living room to the entrance hall. (Courtesy Sam Joseph and Dan Arrighi.)

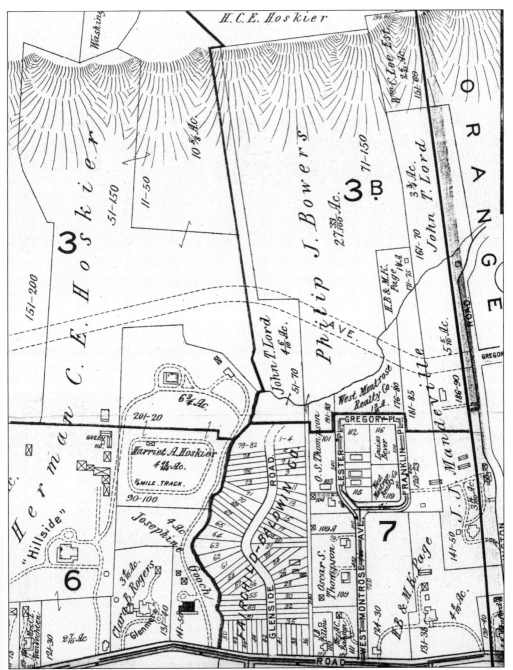

This 1911 map of South Orange featured in *Atlas of the Oranges*, published by A. H. Mueller, shows the Clara B. Rogers property known as Glenmere, the Gooch property known as Linden Lawn, and just above the Fairchild-Baldwin Company tract, the John T. Lord property, where Mountain House Spa was located from 1830 through 1890. In 1830, the Eclipse Stage Line transported guests between the spa and Newark. (Courtesy Sam Joseph and Dan Arrighi.)

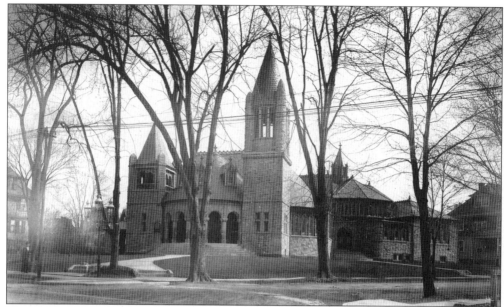

This South Orange Methodist Episcopal Church was built in 1902 to house a growing population. Before 1853, summer services were held on the village green across from village hall for a modest 24-member congregation. After 1853, membership grew to 75. The Civil War recruited many men, and eventually the congregation consisted of women and young boys. The church steps were frequently used by Columbia High School graduating seniors for their class photographs. (Courtesy Seton Hall University Archives and Special Collections Center.)

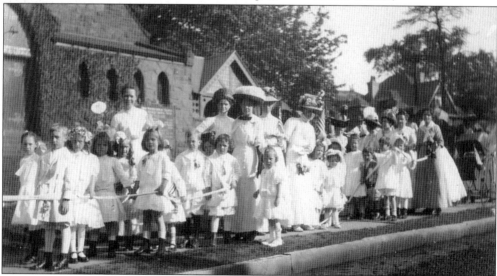

This 1910 class of Sunday school students are holding onto a ribbon so that they will not stray from their teachers as they participate in the annual June Walk. They are walking past the west end of the First Presbyterian Church of South Orange. One can see the porte cochere of the church behind those at the rear of the line, and houses lining Irvington Avenue in the background. The group is about to turn up South Orange Avenue to walk one block to their own house of worship, the South Orange Methodist Episcopal Church. (Courtesy Seton Hall University Archives and Special Collections Center.)

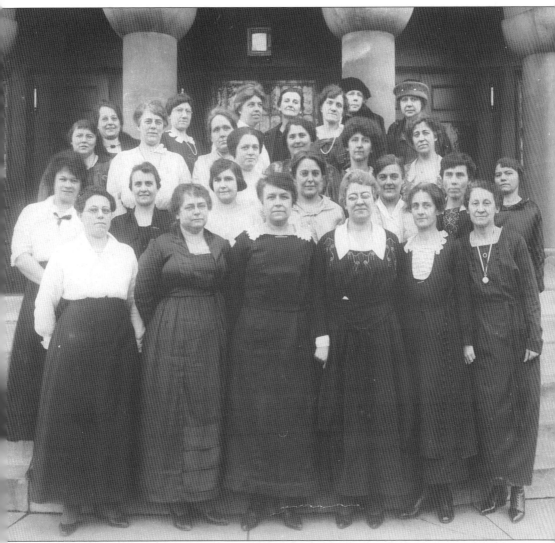

The Opportunity Class of the South Orange Methodist Episcopal Church (1914–1924) is seen here. Included in this picture are (first row) Mrs. Bradbury, Mrs. Harry Lonsdale, Mrs. Frank Foster, Mrs. Pender (minister's wife), Leona Bennett, and Rhonda La Forge; (second row) unidentified, Mrs. Kilburn, unidentified, Millie Hamma, Fannie Evans Smith, Mrs. Harmuth, and unidentified; (third row) Edna Evans, Florrie Evans Tilley, Gertie Herald, Nettie Lyon, Emma Beckett, unidentified, and unidentified; (fourth row) Mrs. Seguine and Miss August Wigman (sister of Mrs. Balevere). (Courtesy Seton Hall University Archives and Special Collections Center.)

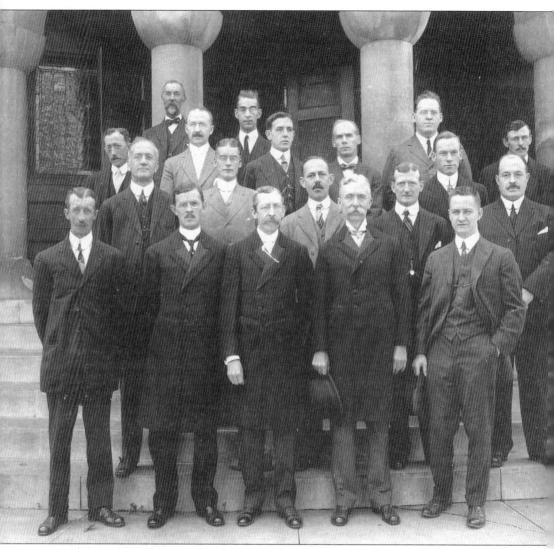

Seen here is the official board of the South Orange Methodist Episcopal Church on September 27, 1914. From left to right are (first row) William W. Tunis, Rev. Perry H. Murdick, Charles G. Fielding, William J. Brown, and Clifford King; (second row) Dr. Taylor (dentist), Charles L. Brown, R. Cunningham (sold buttons), Raymond Brower, Harry Lonsdale, and ? Buzzee; (third row) unidentified, Gus Bird, Ray Cunningham, Frank Foster, unidentified, and unidentified; (fourth row) Frank Stieve (Sexton), John Redfern, and Louis F. Bird. (Courtesy Seton Hall University Archives and Special Collections Center.)

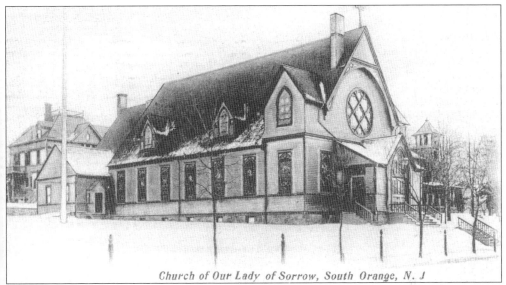

Church of Our Lady of Sorrow, South Orange, N. J

H. Tucker of South Orange printed this 1910 postcard image of Church of Our Lady of Sorrows, located on Prospect Street. This is the present site of Sorrows School on Academy Street. (Courtesy Seton Hall University Archives and Special Collections Center.)

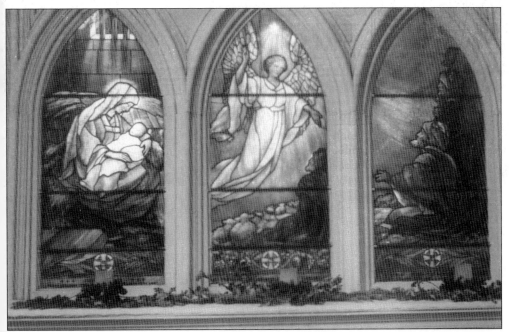

This triptych window at Church of St. Andrew and the Holy Communion located at 160 West South Orange Avenue was donated by Lucy Fenner in memory of her parents, Henry Fenner (1815–1897), one of the church founders, and Mary Tye Fenner (1817–1895). This signed "Louis C. Tiffany of New York" window shows the stable of Mary with Jesus in the first frame, an angel in the second frame, and shepherds in the third frame. St. Andrew was built in 1860 to accommodate 150 worshipers. (Courtesy Church of St. Andrew and the Holy Communion.)

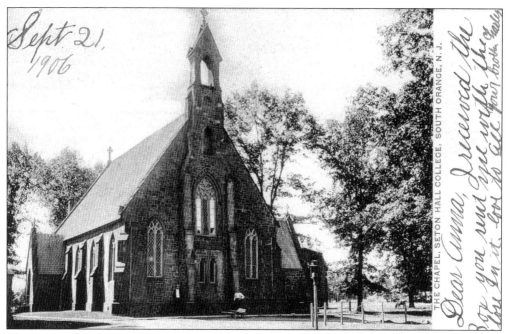

This postcard, sent on September 21, 1906, shows the chapel at Seton Hall College with two laborers on campus. The message reads, "Dear Anna, I received the box you sent me with the close [sic] in it. Love to all your brother Charley." (Courtesy Amy Dahn.)

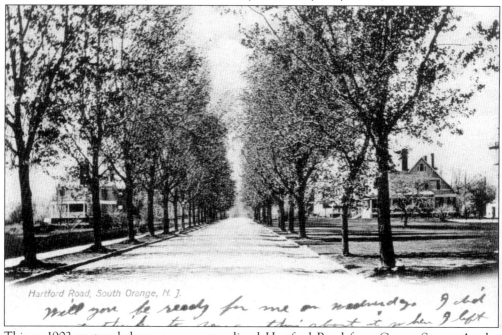

This c. 1902 postcard shows a young tree-lined Hartford Road from Centre Street. At the time this postcard was written, only the recipient's address could be written on the back, and brief messages could be written on the front. This card reads, "Will you be ready for me on Wednesday? I did not think to say anything about it when I left the other day." (Courtesy Seton Hall University Archives and Special Collections Center.)

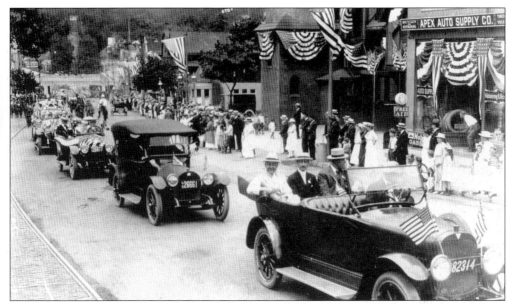

Flag-bearing crowds stand curbside to watch the 1915 Independence Day parade on South Orange Avenue. Flags hang from village hall and stores; they are even draped over automobiles. Village president Francis Speir and two dignitaries are motoring in a brand-new 1916 Hudson Super-Six phaeton; Hudson's 1916 line of cars was introduced in June 1915. The Super-Six set numerous speed records and achieved racing success. In 1916, Hudson also introduced the first "balanced" crankshaft in its six-cylinder engine. This innovation offered unparalleled smoothness, and it was quickly copied, but not before Hudson established the reputation of its Super-Six. (Courtesy South Orange Public Library.)

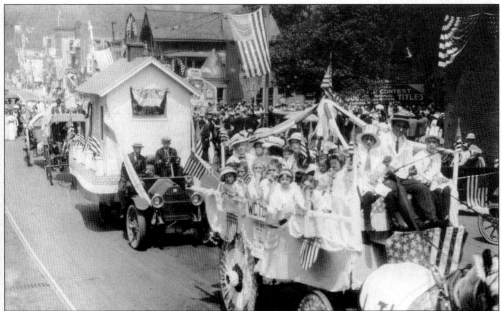

Horse- and automobile-drawn floats make their way up South Orange Avenue as they begin to pass village hall. Flags and bunting drape almost everything in sight. The first float carries children in white outfits; the driver wears a straw boater. (Courtesy South Orange Public Library.)

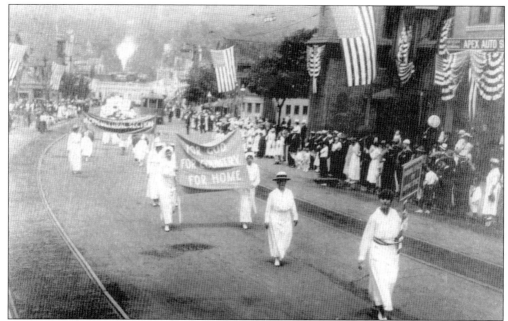

Taking advantage of the 1915, July Fourth Independence Day parade, Marion Rodie (second from right) leads members of the WCTU in a march east on South Orange Avenue. Promoting the evils of drink and the benefits of banning the sale of alcohol was one of Marion's causes. Throughout the early 1900s, Marion and the WCTU were very busy sharing their message. In the background, a steam engine is crossing the recently elevated train tracks. (Courtesy South Orange Public Library.)

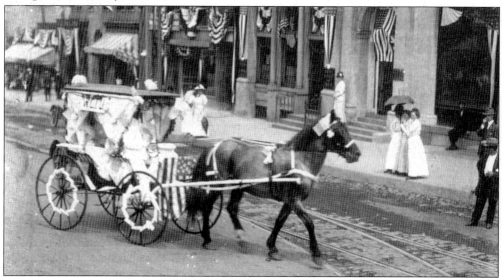

The 1915 Independence Day parade was a big one for South Orange. It included several decorated horse-drawn carriages like the one shown in this photograph. The side banner hanging from the carriage roof promotes the WCTU. The carriage has decorated wheels and is drawn by a horse with a headband. They are preparing to cross the trolley tracks onto the cobblestone section of South Orange Avenue. A 48-star flag hangs from the driver's seat of the carriage. (Courtesy South Orange Public Library.)

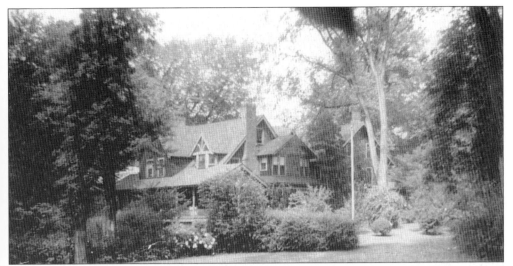

Located in the Montrose Park Historic District of South Orange on Grove Road, the original home predates 1680 and was named in a grant made to Edward and Joseph Riggs and Nathaniel Wheeler. The farmhouse is estimated to have been built between 1666 and 1680 when Dutch settlers arrived in Newark. Renovations in 1877 and 1896 transformed the farmhouse into a Queen Anne, shingle-style mansion. William A. Brewer, president of the Washington Life Insurance Company in New York City, purchased the home from John Gorham Vose. Brewer named the home Aldworth and lived in the home for 50 years, until 1916. Today it is a national landmark. (Courtesy South Orange Historic and Preservation Society and the private collection of Charles W. Foster.)

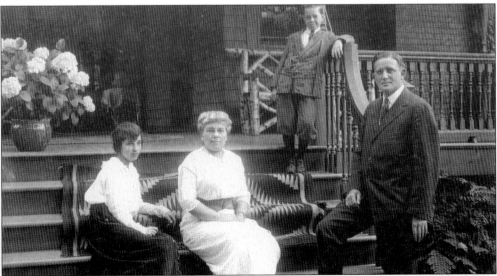

Seated on the front porch of the Old Stone House is Grace Cables Reed, her mother Mary Reed Albee, Francis Cables Reed (standing), and Dr. George C. Albee. At the time of her marriage to Dr. Albee, Mary was a widow with two children. She and her first husband, William Henry Reed (who passed away), are the parents of the children in this picture. This portrait was taken by men from Thomas Edison's company in exchange for using their property for a photograph shoot. (Courtesy South Orange Historic and Preservation Society and the private collection of Charles W. Foster.)

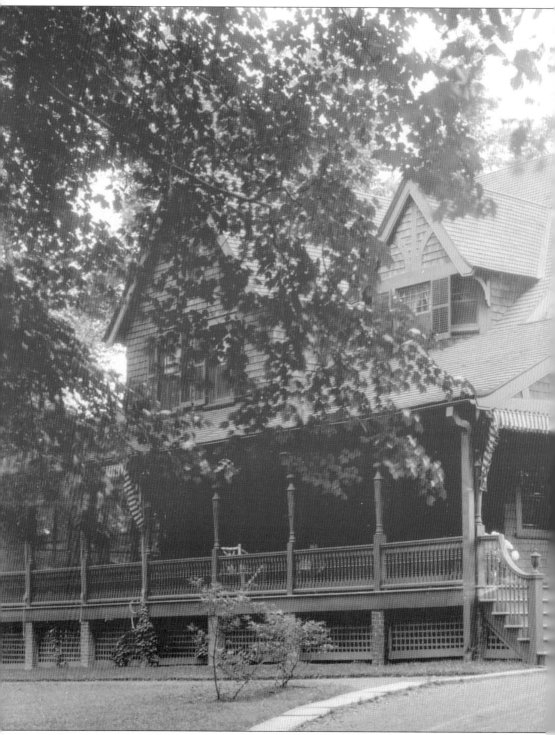

This c. 1918 photograph is of, from left to right, Francis Cables Reed (standing on steps), Grace Cables Reed, Mary Reed Albee, and Dr. George C. Albee. The photograph was taken by photographers from Thomas Edison's company, who used the property for a western film.

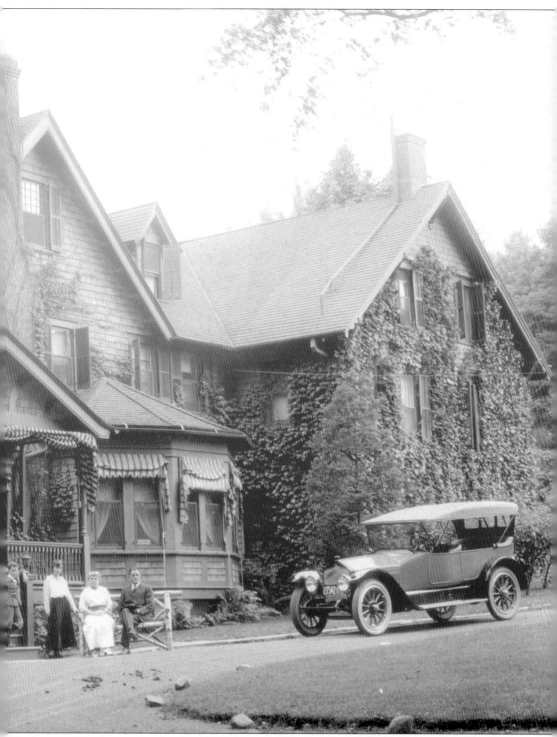

Evidence of the horses having been on the property can be seen in the foreground of this photograph. (Courtesy South Orange Historic and Preservation Society and the private collection of Charles W. Foster.)

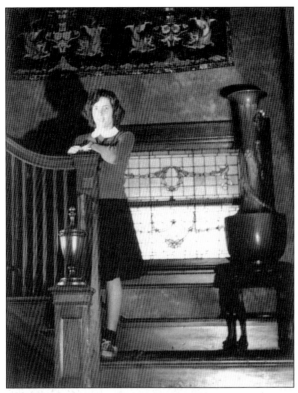

Around 1916, Dr. George Albee and his wife, Mary Reed Albee, purchased this home. In this 1941 interior photograph of the Old Stone House, teenaged Mary Caroline Reed stands in front of stained-glass windows, adjacent to an art deco vase. (Courtesy South Orange Historic and Preservation Society and the private collection of Charles W. Foster.)

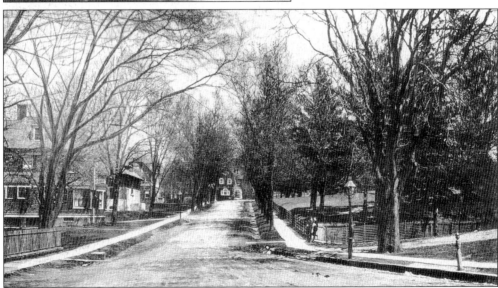

On May 8, 1896, the second building on the left opened its doors to readers as the first space dedicated solely for use as a public library. It is located on Scotland Road at the corner of Taylor Place. Eugene V. Connett donated this property on the condition that $7,500 be "bona fide subscribed for the construction of a library building." This building served as the library until 1926, when a larger building was constructed to house both an adult and children's library. On the right side of the street is the front lawn of the Connett estate. (Courtesy Seton Hall University Archives and Special Collections Center.)

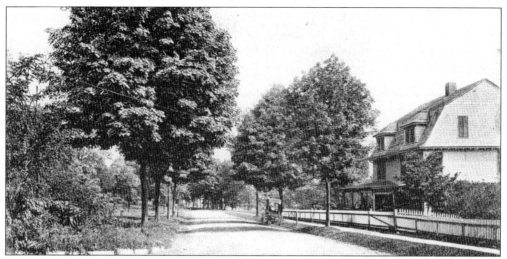

The manufacturer of this postcard misspelled the name of the road, but that does not change the fact that this card features a rural photograph of Abijah F. Tillou's house, after which the road was named. A horse and carriage are parked in front of the house. The South Orange Middle School, on North Ridgewood Road, occupies the property where Tillou's home once stood. The 1909 message on the back reads, "This is Mr. Tillou's house we are having a fine time. Mr. and Mrs. F. E. Brainerd are also here. Home soon. With love, Christine." (Courtesy Seton Hall University Archives and Special Collections Center.)

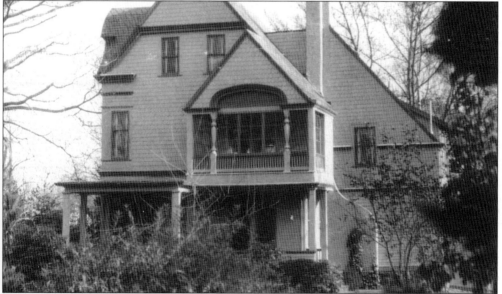

This beautiful 1890 shingle-style home was the home of Carleton and Martha Wolle Riker. Until the 1950s, this home occupied one and a half acres at 190 Montrose Avenue, in the Montrose Park District of South Orange. This 15-room house had a greenhouse on the third floor. Postcards of this house were available so that visitors could send photographs and notes to their friends. In the 1950s, this house was torn down and replaced by a contemporary home. Many beautiful large homes were replaced by new construction, which was seen as sleek, modern, and more efficient. At that time, restoration and architectural preservation were not in style. (Courtesy private collection.)

Henry B. Halsey and his business partner J. Bayard Clark were dealers in lumber, coal, and masons' materials in South Orange; the firm's name was H. B. Halsey and Company. Henry was a descendant of Thomas Halsey, one of the founders of South Hampton, Long Island. A biography of Henry notes that he "belongs to the Masonic fraternity and the Ancient Order of United Workmen, and is an ancient Odd Fellow. He is also a member of the Field Club." Henry served on the town council twice in the late 1800s. Today Halsey Place is named in his honor. (Courtesy Amy Dahn.)

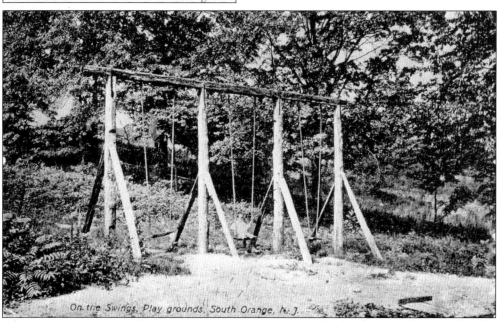

"On the Swings, Play grounds, South Orange, NJ," reads the front of this postcard mailed in 1912 by Ernest W. Murphy. Ernest writes to his friend Dory Jarvis in Jewett, Connecticut. Without regard to punctuation he remarks, "How is everything in Jewett as you go up to Plainfield often my address is 22 Grant St Newark NJ Give my regards to little one the nice dancer From Your Friend Ernest W Murphy."

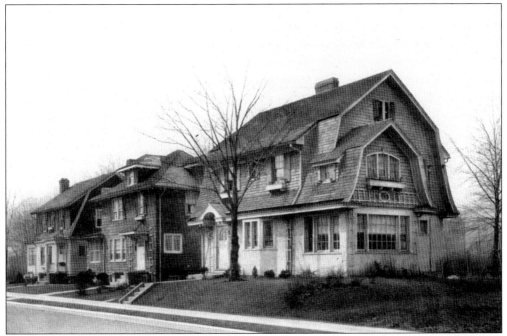

Featured in the 1914 Tuxedo Park Real Estate brochure, this photograph shows three homes on Reynolds Place. The nearest home has a gambrel-style roof and a two-color paint scheme. Notice the trellis work and window boxes for spring plantings. All homes in Tuxedo Park included the latest in services: the streets were paved and had concrete curbing and walks, as well as brick gutters. Water, gas, electricity, and sewers were included. (Courtesy Ford and Geri Livengood.)

By 1914, the Crowley-O'Brien Company had developed the Tuxedo Park neighborhood of South Orange. A sales brochure promoting Tuxedo Park states that it is "at the edge of the city and the beginning of the country." Behind this brick-and-clapboard Colonial home on South Centre Street in Tuxedo Park is undeveloped land. (Courtesy Ford and Geri Livengood.)

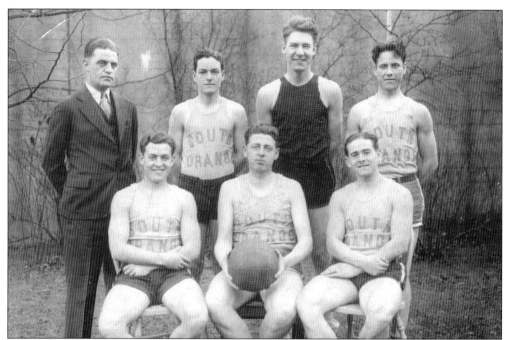

Joseph Farrell, director of the South Orange Department of Recreation for many years, stands (left) for this outdoor photograph with six members of the South Orange basketball team around 1919. In the back row, center is Al Lang, and in the first row, center is Joseph A. Carter. Players wore high-top leather basketball shoes and wool socks on the courts. (Courtesy Eleanor Farrell.)

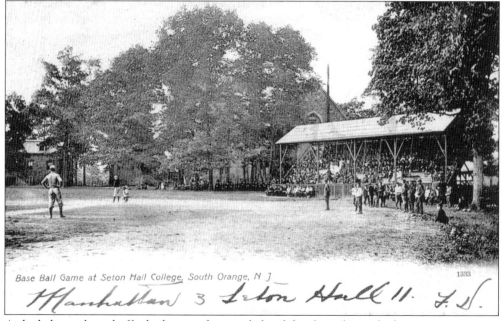

A shaded grandstand affords the crowd a spot behind first base from which to view America's favorite national pastime. In 1906, Seton Hall hosted Manhattan College in a spring game of baseball. To the crowd's delight, the home team won: Seton Hall 11, Manhattan College 3. (Courtesy Seton Hall University Archives and Special Collections Center.)

70

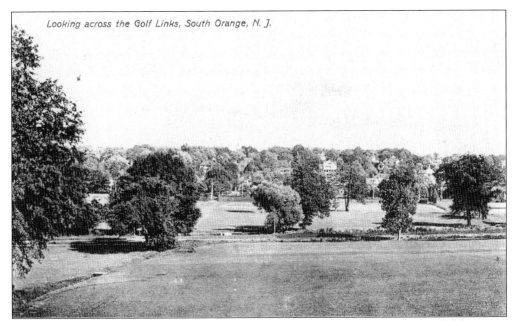

Looking across the Golf Links, South Orange, N. J.

In 1911, the Lone Oak Golf Course was nestled between Ridgewood Road and Meadowbrook Lane. It spanned the area between Meadowbrook Place (known then as West Turrell Avenue) to what is today the north end of South Orange Middle School. The duck pond did not exist at that time. (Courtesy Seton Hall University Archives and Special Collections Center.)

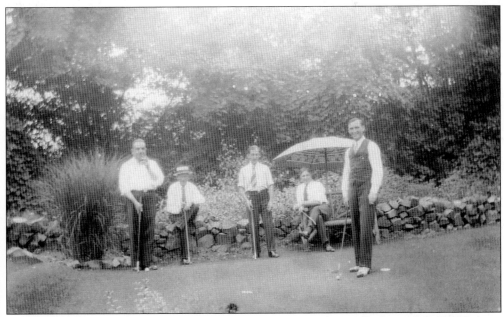

Around 1950, five gentlemen in ties relax before continuing play on the Lone Oak Golf Course. (Courtesy Rose and Joe Zuzuro and Seton Hall Archives and Special Collections Center.)

71

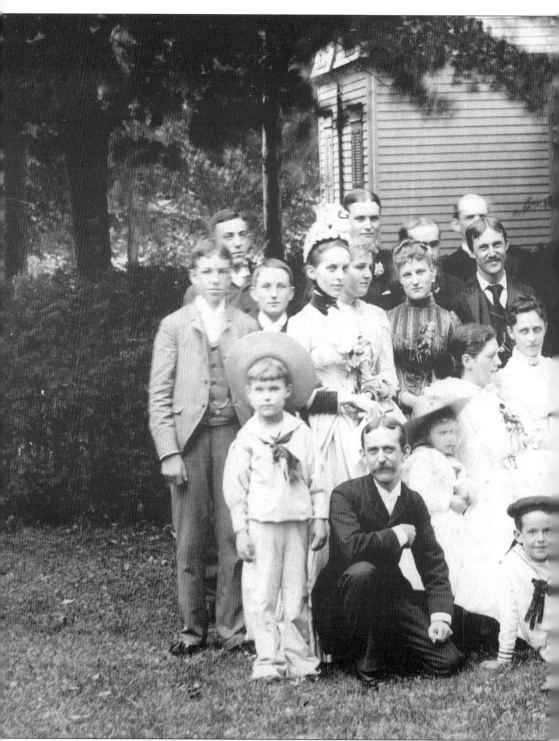

The Thayer family gathers at 140 Montrose Avenue for Sara Fuller Thayer's 21st birthday, in 1888. Sara is holding the bouquet, and to the right is Louise Vose. The home at 140 Montrose is one of the oldest houses in the Montrose area, appearing on the 1873 map of land owned by

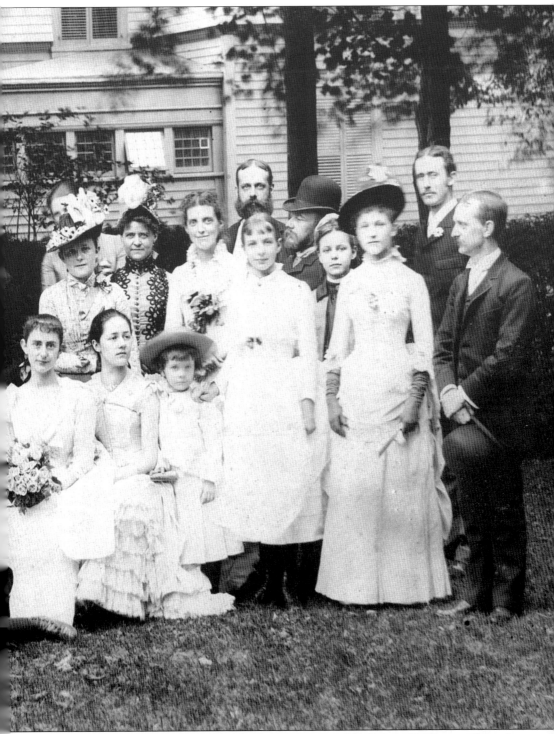

John W. Vose and Lewis Taylor. In 1873, the house was owned by Robert H. Thayer. Through 1911, it was owned by Harriet F. Thayer. By 1928, the house was owned by Alexander M. Craig. (Courtesy David Thayer.)

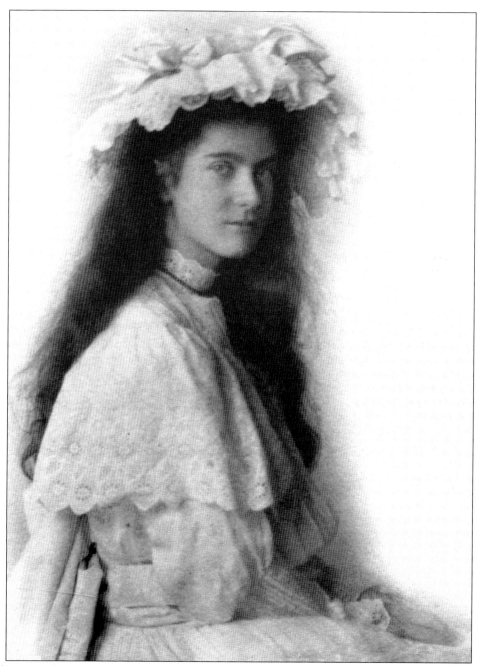

This 1907 photograph shows Anna Appleton Flichtner, who lived at 140 Montrose Avenue with her mother and Thayer grandparents after her father's death, in 1905. The Thayer family was one of the most prominent families at the time; they socialized with the Vose family (Louise Vose was one of Anna's best friends) and other important community leaders. From 1907 until 1978, Anna kept diaries. In those she describes life in South Orange at the beginning of the 20th century. She mentions the Thieriot family at 404 Scotland Road and the Van Vechten family at 52 West Montrose Avenue. Anna attended Miss Lucie C. Beard's Boarding and Day School at 112–124 Berkeley Avenue in South Orange. (Courtesy David Thayer.)

Four

NEW SCHOOLS
AND NEW HOMES
1920–1939

On October 27, 1929, twelve thousand spectators, including 35 major-league ballplayers, brought baseball fever to Cameron Field to watch legendary ballplayers Babe Ruth and Lou Gehrig play in an exhibition game for South Orange. Spectators each paid the $1 admission to squeeze into the grandstands and crowd around the diamond that fall afternoon. Ruth hit a home run into the right-field stands, and Gehrig hit two homers. One of Gehrig's shots traveled 600 feet as it cleared the centerfield wall and Lackawanna Railroad tracks to hit a house on Vose Avenue. Fourteen dozen baseballs were used that day when South Orange defeated New Brunswick 7-6. Today the local Cal Ripkin League's motto is South Orange Baseball: Where Legends Played.

In 1842, P. T. Barnum "discovered" three-foot-four-inch Charles Sherwood Stratton (1838–1883) and popularized him as Tom Thumb in his traveling road show. The marriage of Tom Thumb to Lavinia Warren (another little person) in 1863 was global news, and by the early 1900s Tom Thumb weddings became popular. Typically a group of children (usually a Sunday school class) dressed up in child-size formal wear and acted as members of a wedding party, including a bride, a groom, attendants, and guests. Other "theatrical" matrimonial events included the "womanless wedding," where men dressed as women and performed a wedding sketch. These were generally staged by church members as a way to raise money for various causes.

At Seton Hall, the nickname Pirates was given to the school after a 1931 baseball game in which a five-run, ninth-inning rally resulted in a 12-11 victory over Holy Cross. That win prompted a local sports writer to say, "That Seton Hall team is a gang of Pirates!" In 1932, the Middle States Association gave Seton Hall accreditation.

Marylawn of the Oranges Academy opened its doors in 1935 as a private catholic girls' school. The mission of the academy was (and still is) to prepare, motivate, and challenge young women, intellectually and morally, to assume their roles in society according to Catholic tradition and in the founding spirit of the Sisters of Charity of New Jersey.

In South Orange, the 1920 population was about 7,274 and in 1930 about 13,630. Village presidents included Edward D. Duffield, William S. Hunt, George H. Becker, Harry J. Schnell, Dudley W. Figgis, and E. Morgan Barradale.

Headline news included the beginning of Prohibition's 13-year reign, women in the United States winning the right to vote (1920), Lindbergh's first solo flight across the Atlantic, the New York Stock Market crash, and in 1928, Sonja Henie's (1912–1969) winning of the first of three consecutive Olympic gold medals (1932 and 1936) in figure skating.

Inventions included Kodak's 16-millimeter movie film, the first "talkie" film (*The Jazz Singer*), Sir Alexander Fleming's "accidental" discovery of penicillin, and Marconi's first successful transatlantic radio transmission.

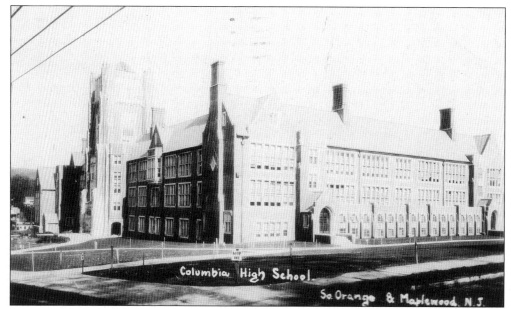

This postcard shows Columbia High School around 1930 with no foliage. A sign that reads, "Keep Off" is posted in a roped-off section of ground where landscapers are trying to grow grass. The message on this postcard reads, "Received your card a few days ago. This school was erected a year or two ago in South Orange and is a very fine institution. A.E. Scott." It is addressed to Miss Ruth Vail of 510 Linden Avenue, Long Beach, California. (Courtesy Seton Hall University Archives and Special Collections Center.)

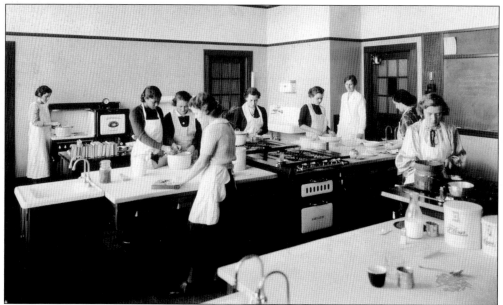

A girl's education would not be complete without proper training in home economics. This c. 1906 photograph shows a class of apron-clad students cooking over gas stoves. Laboratory-style faucets and porcelain sinks offer ease in cleaning up after class. Under the direction of the teacher who is wearing the white coat, the classroom is stocked with flour, sugar, bottled milk, and numerous cookbooks. (Courtesy Columbia High School.)

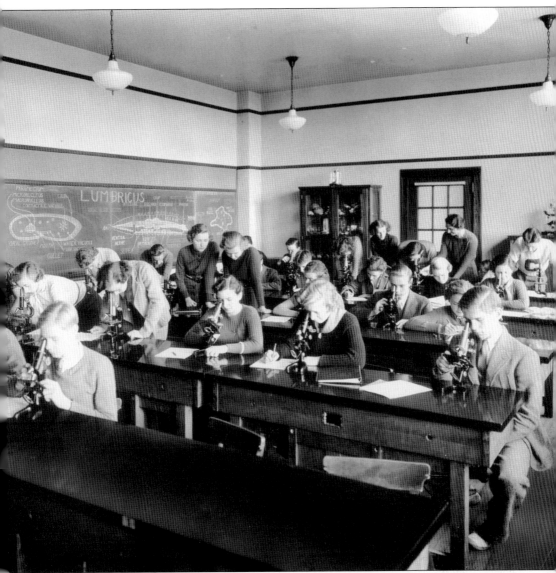

Columbia High School students in the 1930s participate in a science class by peering into their microscopes and studying slides of earth worms. On the blackboard, the teacher has drawn pictures and printed the word *Lumbricus*, the binomial nomenclature for segmented worms. A student wearing his varsity sweater can be seen in the back of the classroom. (Courtesy Columbia High School.)

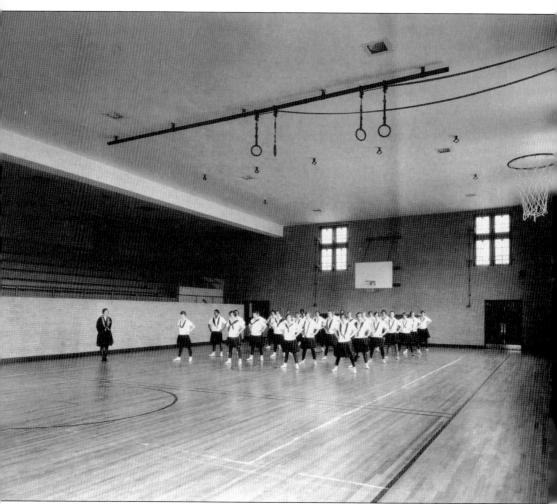

Healthful activities were not just for boys. The expansive facilities at Columbia High School included two full-sized gymnasiums: one for boys and one for girls. Between the gymnasiums was a tile-lined swimming pool. Locker rooms were also strategically placed between both gymnasiums and the swimming pool so that they could be utilized for both activities. In this c. 1930 photograph, the teacher is instructing her pupils in calisthenics. On the left side of this photograph are permanent modern concrete bleachers, which span the length of the gymnasium. (Courtesy Columbia High School.)

The sparking new *c.* 1927 cafeteria at Columbia High School featured wooden tables and Colonial-style wooden chairs. The background is the kitchen preparation and serving area. (Courtesy Eleanor Farrell.)

Wallace and Tierman Company, Incorporated, manufacturers of chlorine control equipment, promoted their recirculation equipment that was installed in the new pool at Columbia High School. Their advertisement, found in the February 1928 *American School Board Journal* announces that "The students at this outstanding High School 'swim in drinking water.' They claim that since every drop of swimming pool water is chlorinated, it is as pure as drinking water."

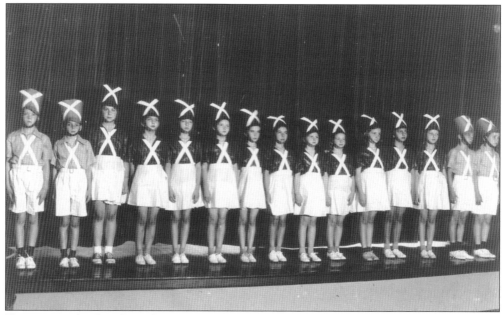

Elementary school students dress as toy soldiers in a Christmas program they put on at Marshall School. Shown from left to right are Jack Merselis, Walter Mook, Laura Jane Klein, Betty Troup, Martha Riker, unidentified, unidentified, Barbara LeMare, Susanne Eustis, Mary Campbell, Sheila Mortenson, Adrianna Williams, Madelyn Goerke, Sumner Williams, and Dick Safferstein. (Courtesy Martha Riker Trundle.)

An article in the 1927 *American School Board Journal* explains that Henry W. Foster, the superintendent of schools, advocated the reorganization of the schools into a junior high school system of six-three-three organization. Elementary schools were to be kindergarten through grade six; junior high grades seven to nine; and senior high grades 10 through 12. Marshall School (1922) was the first elementary school built after World War I, Montrose School was built in 1924, and South Mountain School was built in 1929 to serve children in the West End neighborhood, which was then known as the South Orange Ridge area. (Courtesy Steve Weintraub.)

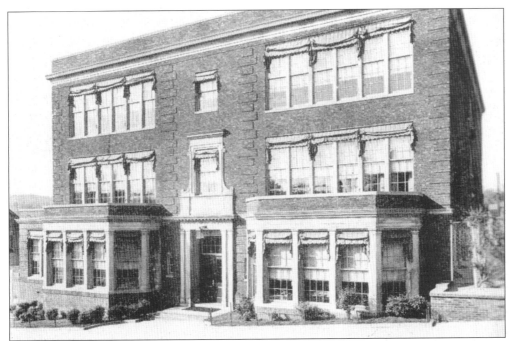

The First Street School educated youngsters in the Church and Academy Street neighborhoods. Notice the awnings over each window to help keep classrooms cool during the warmer months that school is in session. In the 1980s, when school enrollment dropped, the First Street School was sold to private investors. Today it is home to medical spaces and a fitness center. (Courtesy Eleanor Farrell.)

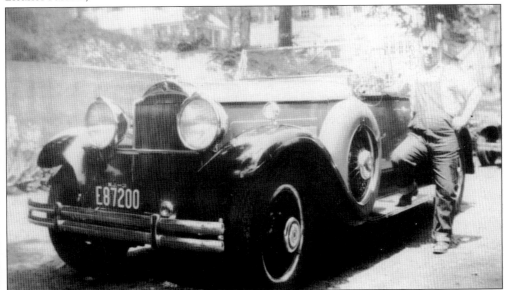

Driving and maintaining this snazzy 1931 Packard convertible car was just one of Hugh Turner's responsibilities when he was a live-in houseman at 303 Montrose Avenue from 1931 to 1935. Homeowners Fricke and Ida Rodewald and their family had Turner drive them to their New Jersey summer shore house, where he dressed in a white cotton jacket to serve the Rodewalds and their guests. (Courtesy Hugh Snyder.)

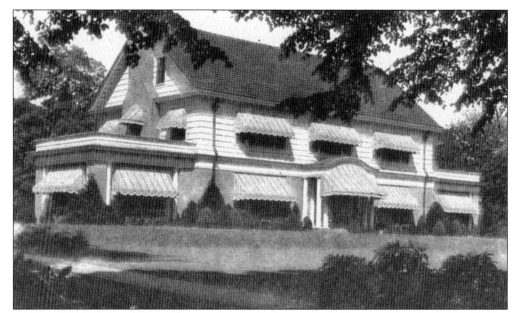

Listed in *Gems of the Oranges*, George W. Lethbridge lived in this home at 303 Montrose Avenue around 1923. By 1931, the house was owned by Fricke Rodewald and his wife, Ida. During the 1930s, the Rodewald family employed Hugh Turner, a Scottish immigrant, as a live-in butler/houseman/chauffeur. When the gentleman left his employer, Ida Rodewald provided him with a fine letter of recommendation written on "303 Montrose Avenue" letterhead, which read in part, "Hugh is honest, has a good disposition and is a splendid and cheerful worker – does not drink or smoke." (Courtesy Hugh Snyder.)

Hugh Turner, butler, chauffeur, houseman, and all-around helper, "lived in" with his employers Fricke and Ida Rodewald at 303 Montrose Avenue from 1931 to 1935. He is shown here with one of the Rodewald children, shoveling the front walk after a snow storm. (Courtesy Hugh Snyder.)

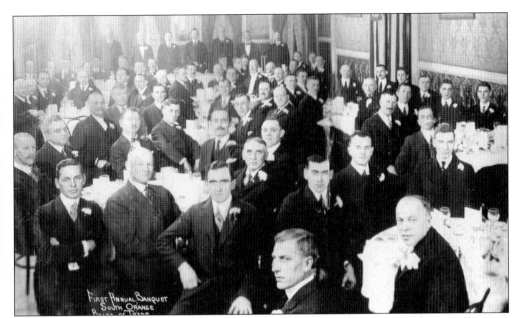

A board of trade is defined as any person or group of persons engaged in buying or selling any commodity or receiving any commodity for sale on consignment. The South Orange Board of Trade would be businessmen who are involved in sales, retail, commercial, or services in the village of South Orange. This photograph shows them at their first annual banquet on February 9, 1920. The gentlemen are all wearing three-piece suits and sporting boutonnieres. (Courtesy Montrose Park Historic District Association, gift of John P. Farrell.)

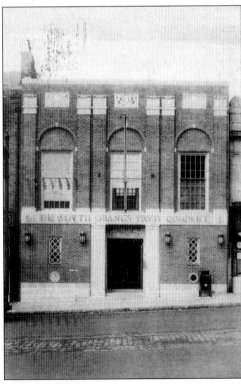

In 1938, the South Orange Trust company was located on South Orange Avenue, near the railroad tracks across from Sloane Street. Typically, depositors were inspired by a bank with a strong presence. People understood that the sturdier the building, the more reliable the bank. With the country coming out of the Depression, the Federal Deposit Insurance Corporation (FDIC) was more important than ever. In 1933, Congress and President Roosevelt developed the FDIC to guarantee deposits and boost public confidence in banking. (Courtesy Seton Hall University Archives and Special Collections Center.)

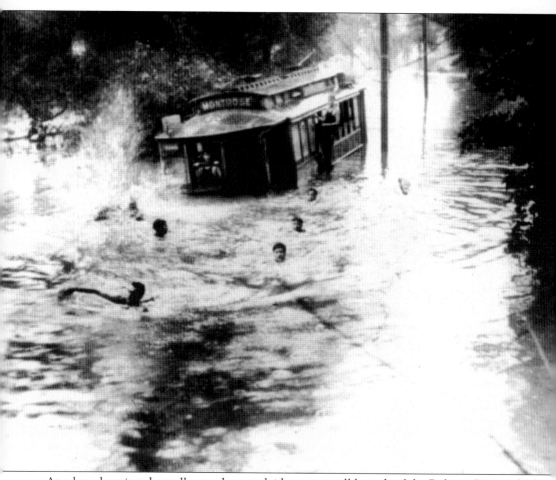

At a low elevation the trolley tracks were laid near a small branch of the Rahway River, which runs through South Orange. This photograph was taken around 1930 when the brook became a river and overflowed, lifting the car off its tracks. This trolley is on the Montrose route, near Mountain Train Station. Young boys in one-piece t-shirt-style swimsuits have decided to rescue the distressed trolley. One swimmer stands on the side of the car, and another is inside, with his hands resting on the lowered window. (Courtesy Richard Farrell.)

This Dutch Colonial home is located at 252 West End Road and represents cozy homes that were built in the first half of the 20th century for families who were looking for modern kitchens, quiet neighborhoods where they could raise their families, and excellent access to public transportation to Manhattan. Around 1960, this house was the residence of John J. Daly. (Courtesy Eleanor Farrell.)

Around 1920, this realtor's photograph shows an example of the continually popular Tudor Style home. The family car is parked in the unpaved driveway. To own a home and a car were symbols of achieving the "American Dream." The license plate of the car reads E84457, and the tire cover advertises the automobile's hydraulic brake system. (Courtesy Roy Scott.)

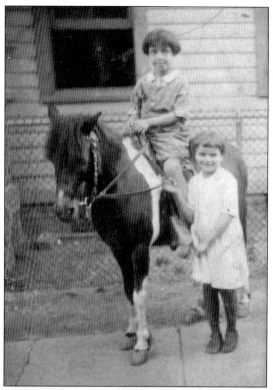

In the summer of 1927, an enterprising photographer trotted his easy-going pony around South Orange neighborhoods and took photographs of children sitting atop his pony. In this photograph, Helen Konkowski (age 9) sits on the horse while her younger sister, Eleanor (age 6), who was too scared to climb into the saddle, stays on solid ground. (Courtesy Eleanor Farrell.)

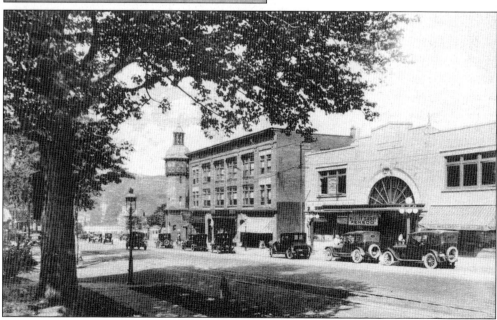

The Cameo Movie Theater, shown in this *c.* 1922 postcard of South Orange Avenue, was a haven every Saturday for children who saved their money all week for tickets to the afternoon movies. A banner hanging in front of the ticket booth promotes the hit comedy *Penrod*, starring Wesley Barry as Penrod. The *Penrod* series featured the wacky adventures of a preteen boy and his friends. (Courtesy Seton Hall University Archives and Special Collections Center.)

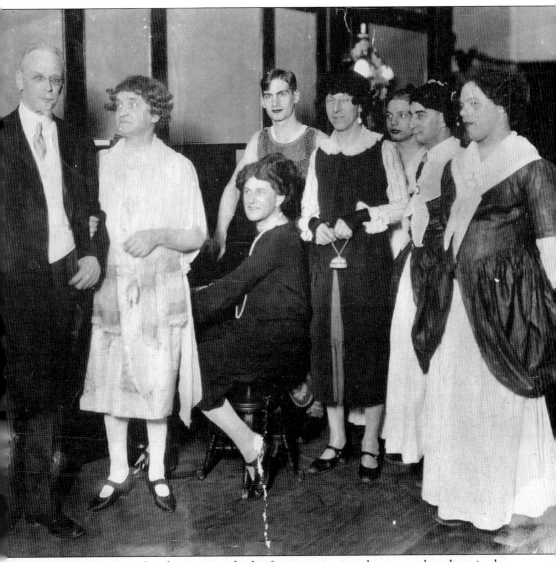

Without the ease of travel and various methods of communication that came along later in the 20th century, members of the Methodist Episcopal church in South Orange found creative ways to entertain themselves. In 1925, they held a womanless wedding (men dressed themselves as women). In many instances churches and clubs used womanless weddings as a way to raise funds for various causes. From left to right are (first row) Henry Geire, Will Clark, Edward Balevere, Bob Wintringham, Dr. John Redfern, and Joseph Brandbury; (second row) Arthur Coe and unidentified. (Courtesy Seton Hall University Archives and Special Collections Center.)

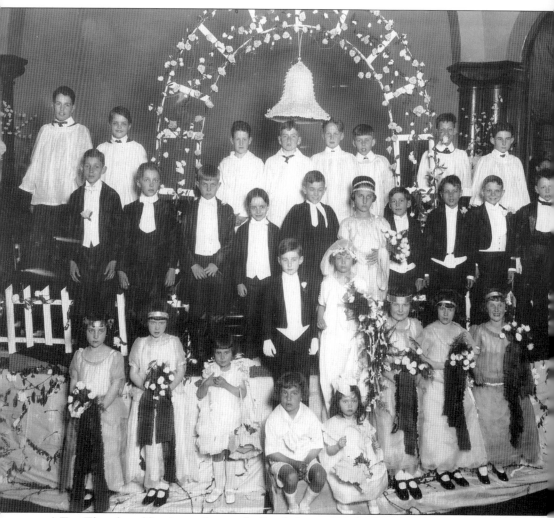

A Tom Thumb wedding is seen here at the South Orange Methodist Church on Thursday evening, May 3, 1923. The bridal party consisted of a minister, Vincent Cunningham; groom, Douglas Bennett; best man, Gordon Harmuth; bride, Mary Edna Jensen; maid of honor, Eleanor Bowen; bridesmaids, Elinor Stein, Helen Rockefeller, Jane Redfern, Margaret La Mon, Jane Baldwin, and Mary Young; flower girls, Arlene Beckett, Muriel Cadmus, Mildred Mellor, and Frances Johnson; ring bearer, Clifford Engler; messenger, Robert Coe; parents of the bride, Raymond Bell and Alma Hardy; parents of the groom, Warren Scott and Elinor Engler; grandmother of the bride, Barbara Burr; and grandmother of the groom, Leona Folkner. (Courtesy Seton Hall University Archives and Special Collections Center.)

Hemlock Falls, located in South Mountain Reservation, was a very popular destination for people who wanted to take a Sunday afternoon walk. Several postcards have appeared with spring and summer views of the falls, but this unusual c. 1908 view shows the falls frozen in winter. (Courtesy Seton Hall University Archives and Special Collections Center.)

In this early-1930s photograph the foundations of the South Orange Post Office have just been completed. To the right of the post office was Wells Cadillac, a dealer for new models of Cadillac, LaSalle, and Oldsmobile, as well as used cars. In the distance are homes on Taylor Place, several of which were torn down to make way for village parking. (Courtesy South Orange Post Office.)

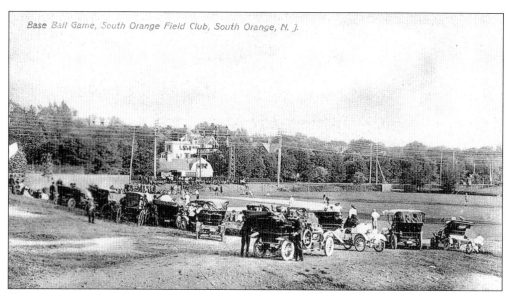

Base Ball Game, South Orange Field Club, South Orange, N. J.

Spectators arrived in their automobiles to enjoy a game of baseball at the Field Club in South Orange. This c. 1920 postcard hints at the enthusiasm South Orange residents had for baseball. (Courtesy Amy Dahn.)

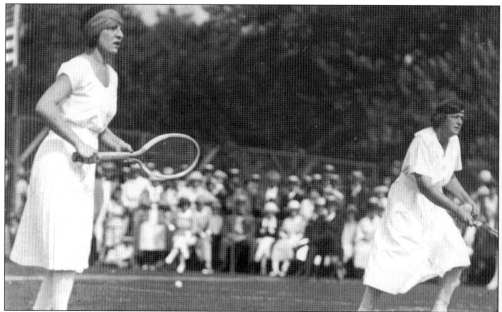

At the 1920 Summer Olympics, France's Suzanne Lenglen abandoned the customary tennis garb for a short, pleated skirt, sleeveless silk blouse, and matching sweater. She won two gold medals and a bronze medal, and became the first female celebrity athlete. In this c. 1927 photograph, Lenglen (1899–1938) plays in a doubles match with Mrs. David C. Mills at the Orange Lawn Tennis Club. As an amateur, Lenglen competed in the 1920 Olympic Games in Antwerp, Belgium. Lenglen became a professional tennis player in 1926 and participated in the 1927 United States professional tour. Lenglen was a doubles and singles champion in both France and England. She was also the author of several books on tennis including *Lawn Tennis for Girls*. (Courtesy Orange Lawn Tennis Club.)

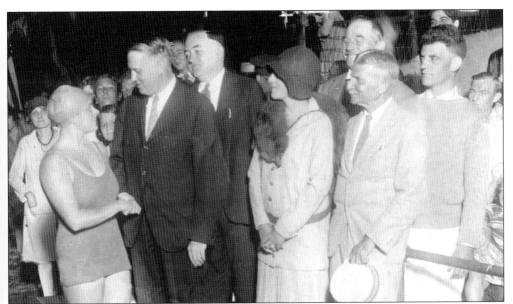

Olympic diving champion Aileen Riggin (1906–2002) visited South Orange in 1929. At age 14, Riggin won the gold medal for women's springboard diving at the 1920 Summer Olympics in Antwerp, Belgium, becoming America's youngest gold medalist. She went on to win silver and bronze medals for springboard diving and backstroke at the 1924 Olympics in Paris. During her 1929 promotional tour, Riggin visited South Orange's Cameron Field Pool, the Orange Lawn Tennis Club Pool, and the Columbia High School pool to promote her views that children should be taught to swim before they were 10 years old. She said that after that age, it would be more difficult to learn swimming. (Courtesy Eleanor Farrell.)

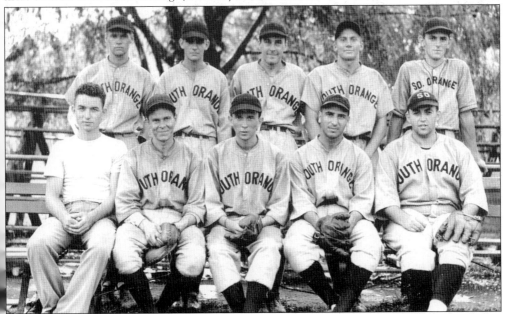

The South Orange baseball team takes a seat on the bleachers in Cameron Field for a photograph. Buddy Farrell, who as an adult became the director of Parks and Recreation, is seated in the first row, on the left. (Courtesy Eleanor Farrell.)

SOUTH ORANGE VILLAGE BOARD OF RECREATION

COMMISSION BASE BALL COMMITTEE

As of July 7, 1930

RECEIPTS

ash Received from 1929 Accounts $
 " " from Games to date 2,
 " " from Program
 $3,

DISBURSEMENTS

irst Game $
econd "
hird "
ourth "
ifth "
ixth "
eventh"
inth "
enth "
wo Cash Boxes
at Strong (Services as per agreement in securing Ruth &
 Gehrig at last game 1929)
hree Weeks Tickets & Posters
dvertising (Distributing Signs) H. J. Sutton
 " " " A. Mac Lockwood
 " (Newark Star Eagle)
aseballs (Two Dozen)
yping Special Report (A. M. Wasil)
anner (Carlton Sporting Goods Co.)
ash on Hand July 7th, 1930
 $3,

In 1930, the Recreation Commission of the Base Ball Committee presented a statement of receipts and disbursements dated July 7, 1930, to the South Orange Village Board of Recreation. In the disbursements section of the statement is an item for "Nat Strong" who is being paid $75 for services he rendered in securing Babe Ruth and Lou Gehrig when they played in South Orange on October 29, 1929. (Courtesy Eleanor Farrell.)

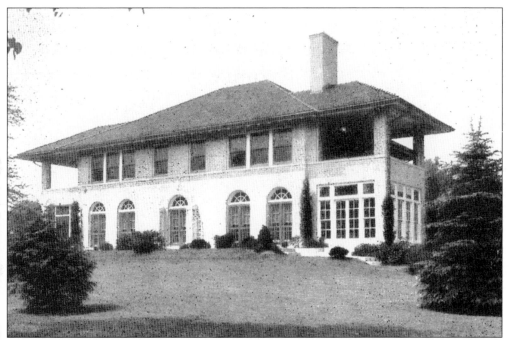

Noted architect William Lehman designed and built this Italian Renaissance–influenced home around 1921 for his wife, Carolyn, and their family. They lived at this Warwick Avenue residence until about 1947. Through his family-owned Newark architectural firm, Lehman designed much of what is known as Newark today. Several of his buildings include the federal post office, the federal courts building, and the Bell Telephone building. He also designed the Tudor-style stores in Upper Montclair, along Valley Road. Lehman died on July 30, 1951, at age 77. (Courtesy South Orange Public Library.)

Western expansion in the late 1920s resulted in a brand-new South Orange Avenue that was laid with a gravel base. On the right is a gas lamp, and in the distance on the other side is another gas lamp. New sidewalks and plantings lead drivers and pedestrians to the Newstead section of South Orange, which was developed around 1930. (Courtesy Roy Scott.)

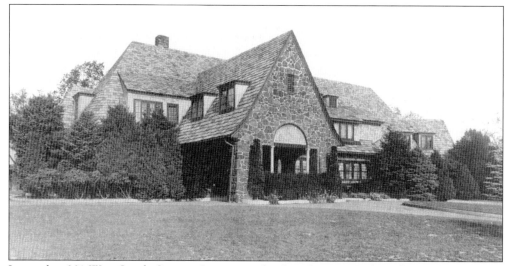

Located at 301 West South Orange Avenue is a brick-and-stucco Tudor-influenced house with a massive slate roof. The slate is graduated to accentuate the roofline and create an illusion of height. In the 1960s, it was the home of George Douglas Hofe. Around 1979, developers purchased the home, gatehouse, carriage house, and surrounding property in order to build condominiums. The main house is used as a gathering place for members of the Village Green Condominium Association. The former backyard now features a pool complex. The original gatehouse remains on West South Orange Avenue. (Courtesy Eleanor Farrell.)

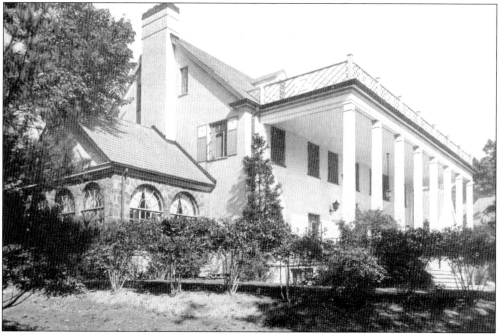

In the late 1920s and early 1930s, George H. Becker developed a new neighborhood on the west end of the village, which became known as Newstead. The new houses were a mix of traditional and contemporary homes that appealed to residents who wanted a change from 19th- and early-20th-century homes. Located at 56 Crest Drive, this Newstead home, seen around 1960, was the residence of Col. William Freiday. (Courtesy Eleanor Farrell.)

Five

STUDENTS, SWIMMING, AND ICE CREAM
1940–1959

In 1911, Rev. Lewis Cameron of the South Orange Episcopal Church deeded land to the village for use as a free public playground. Built in the mid-1920s, the South Orange municipal pool was the first free municipal pool in the country. Pool escapades included throwing in rocks, rafts, and once, a small turtle to see how it fared in chlorine. Then there were chicken fights, dunking, and gold fish hunts. After two hours of trying to survive in chlorinated water, the fish gave up and died. Scheduled swimming was considered de rigueur, but no one went into the pool until an hour after they had eaten.

Edward Stratemeyer (of the Stratemeyer Syndicate) lived in neighboring Maplewood, and it has been said that the concept of the first Nancy Drew mystery, *The Secret of the Old Clock* (1930), was inspired by the South Orange Village Hall clock. One of his most prolific writers was Howard R. Garis (1873–1962), whose granddaughter attended the private girls' school Marylawn of the Oranges Academy. Garis wrote most, if not all, of the first 36 volumes in the Tom Swift series and the created Uncle Wiggily series.

On December 7, 1942, Japanese fighter planes attacked Pearl Harbor at around 7:00 a.m. Honolulu time—noon, South Orange time. Residents were riveted to their radios. At Seton Hall, the raid on Pearl Harbor prompted coach John "Honey" Russell to cancel a coaching clinic scheduled for the next day. Many Seton Hall students entered the armed forces, but the school remained in session throughout the war years. In 1946, a total of 94 percent of Seton Hall students were World War II veterans.

The 1940 population was estimated to be 13,742, and in 1950, 15,230. Village presidents were E. Morgan Barrandale, Spencer Miller Jr., James A. O'Hearn, Couternlay Overman, Jack Augenblick, and William C. Kruse.

Residents were reading headlines about Jesse Owens's four gold medals at the Berlin Olympic Games; the explosion of the zeppelin *Hindenburg* over Lakehurst, New Jersey; and the beginning and end of the United States' involvement in World War II. Chuck Yeager broke the sound barrier, Roger Bannister ran the first sub-four minute mile (3 minutes, 59.4 seconds), the United States launched the first of many satellites, and electronic computers were used in research, industry, and commerce.

New inventions included nylon, antibiotics, the transistor radio, long-playing records (LPs), and Dr. Jonas Salk's polio vaccine. Bette Nesmith Graham invented Liquid Paper (originally called "mistake out") and marketed it herself after 3M refused to buy it (1955). Bette is the mother of Michael Nesmith, one of the original band members of The Monkees (and the mid-1960s television show by the same name).

Marylawn of the Oranges Academy's first classes were held in the Graves estate located at 425 Scotland Road. Eventually the school took over the Stewart estate, and later Marylawn purchased the Gilligan estate. What were once three estate properties on Scotland Road at the beginning of the 20th century became home to the private academy. Today Marylawn occupies Scotland Road property from Stewart Place to Montrose Avenue. Standing on the steps of the Graves building with Sr. Maria Helen Smith, Marylawn's first principal from 1935 to 1941 (back row, right), are grammar school students. Included in this picture are Peter Henderson, Bonnie Devine, Gertrude Fagan, Nancy Grant, Anne Maguire, Edward Darwin, and Joseph Henderson. (Courtesy Marylawn of the Oranges Academy.)

Children who celebrated their first communion stand on the steps of the Graves building in 1942. From left to right are (first row) Gertrude Fagan, unidentified, Mary Henderson, young master Grant, unidentified, Pat Fagan, and Anne Maguire; (second row) unidentified, Marianne Lifer, unidentified, Eleanor Baron, Marilyn Catgut, unidentified, and unidentified. (Courtesy Marylawn of the Oranges Academy.)

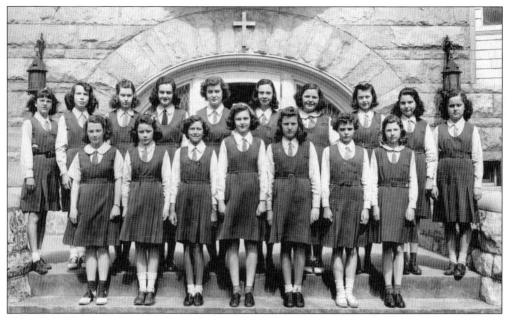

This 1944 photograph was taken of seventh- and eighth-grade students on the front steps of the Graves estate (the main building). From left to right are (first row) Mary Henderson, Winifred Maguire, Carroll Clancy (her grandfather, Howard Garis, wrote Uncle Wiggily books), Mary Adele Eibell, Virginia Igol, Betsy Lantry, and Eleanor Hanley; (second row) Jean Bain, Ann Marguior, Betty Jane Schreiber, Dorothea Adams, Margorie Menk, Jane Murphy, Mary Sue Quigg, Mary Louise Regan, Betty Carlson, and Irene Napp. (Courtesy Marylawn of the Oranges Academy.)

Marylawn student Carroll Clancy's grandfather, author Howard Roger Garis, wrote hundreds of children's books, most notably the Uncle Wiggily books. Garis was also a prolific ghostwriter for the Stratemeyer Syndicate, founded by Edward Stratemeyer who lived in neighboring Maplewood. Under the pen name of Victor Appleton, Garis wrote the Tom Swift stories. He also wrote volumes 4 through 28 and 41 of The Bobbsey Twins series under the pen name of Laura Lee Hope. Garis wrote the Motor Boys series under the name of Clarence Young, and he also wrote the Great Marvel series and stories of Baseball Joe under the name of Lester Chadwick.

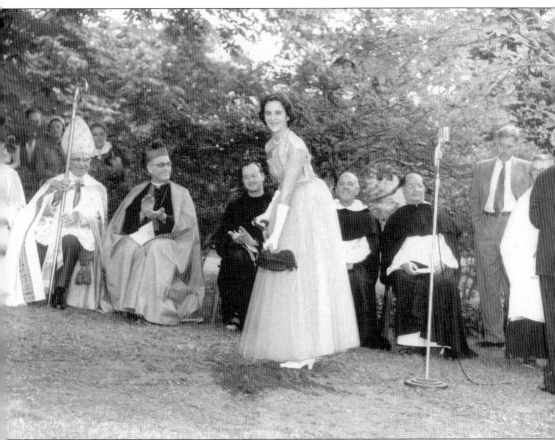

On June 8, 1955, a dinner dance was held at the Chanticleer in Milburn to raise money for the new high school building at Marylawn. Guests paid $25 per couple, and the invitation included the notation "Dress Optional." On June 10, 1956, groundbreaking ceremonies were held at the building site, which was on the southwest corner of Montrose Avenue and Scotland Road. Anita Magovern, student council president, wears a long gown and white elbow-length satin gloves to turn over the first shovel of dirt. (Courtesy Marylawn of the Oranges Academy.)

In the early 1940s, classrooms were needed to house the growing student body at Marylawn and when a third estate became available, the congregation bought the property. For the next 10 years, the Gilligan property located on the corner of Scotland Road and Montrose Avenue stood empty. When enough funds were raised, a new high school was built and completed in 1957. The first class to graduate in this new school was the class of 1957. Until the end of that school year, both the Stuart estate and the Graves estate were used to allow for the finishing touches to be put on the new high school. (Courtesy Marylawn of the Oranges Academy.)

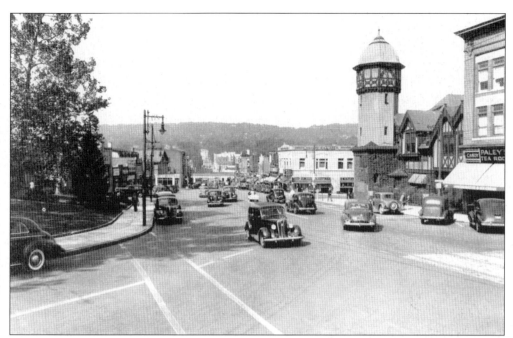

This *c.* 1940 photograph shows cars traveling along trolley tracks on South Orange Avenue at the intersection of Academy Street. The store east of village hall is Paley's Tea Room. The awning reads, "Luncheonette and Ice cream" and promotes candy. (Courtesy Eleanor Farrell.)

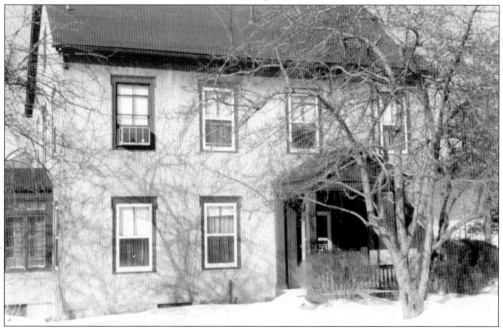

The Farrell home was located on the playground near Meadowland Park. South Orange provided a residence for the director of parks and recreation and his family. Nearly every day throughout the summer, free activities were scheduled to keep local children busy, interested, and challenged to learn new arts, crafts, and sports including pet shows, kite-making competitions, sack races, and marbles tournaments. (Courtesy Eleanor Farrell.)

Children are shown around 1958, splashing and frolicking in the first free community pool in the country. The property became known as Cameron Field and remains today as a public playground that residents use for a variety of sporting activities. In 1972, a new $400,000 Olympic-sized pool, intermediate pool, and wading pool were built. Today South Orange residents swim for a nominal annual fee of $15 per person. (Courtesy Eleanor Farrell.)

Local dignitaries dedicated the skate house in this 1946 ceremony. Shown fifth from the right is Joseph Farrell, head of the Parks and Recreation Department. (Courtesy Eleanor Farrell.)

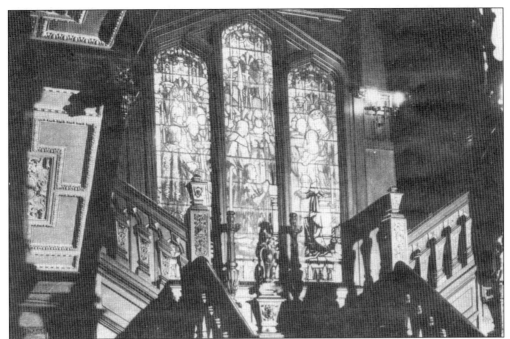

These stained-glass windows depicting biblical scenes are shown here in their original location at the Riker mansion on Scotland Road. After Temple Israel purchased the mansion, they donated the windows to the First Presbyterian Church where they were installed around 1948. For several years before Temple Israel moved into their own home, Rev. Charles Mead of First Presbyterian Church invited the congregants to hold services at their church. Today the Riker Mansion is known as Temple Sharey Tefilo-Israel. (Courtesy Martha Riker Trundle.)

This 1945 winter photograph shows 1 Halsey Place, the home of the Zurkow family. The street signs show the home as being at the intersection of Halsey Place and Halsey Place. Built around 1920, it is a two-and-a-half, three-bay, rectangular wood frame, stucco-clad Colonial Revival home. By 1950, the family enclosed the original wooden porch, and around 1953, added a 24-foot-by-24-foot family room to the right side of the home that featured cork floors, wood paneling, and central air conditioning. (Courtesy Susan Zurkow Frey.)

Maintaining street-crossing safety was the responsibility of John, the policeman who helped elementary students walk safely to Marshall School, the first elementary school built in South Orange, located in the Montrose Park district. Marshall opened its doors in the fall of 1922 and was home to students in grades kindergarten through six. The school was named after James Marshall, a member of the board of education. This c. 1952 photograph shows policeman John standing at the intersection of Turrell Avenue and Grove Road. The home behind John is 301 Grove Road, and the home at the right side of the photograph is 309 Grove Road. (Courtesy Susan Zurkow Frey.)

In February 1951, second-grade students at Marshall School celebrate winter by drawing snowmen and holding other large pieces of art they have just completed. Standing sixth from left is Susan Zurkow. Other students are Christine Troedson, Linda Lally, and Margaret Osborne. At this time, Marshall School did not have a cafeteria and children went home for lunch. By the time students reached sixth grade, they could walk along Grove Road to South Orange Avenue to buy a grilled cheese sandwich at a small restaurant named Cricklewood. (Courtesy Susan Zurkow Frey.)

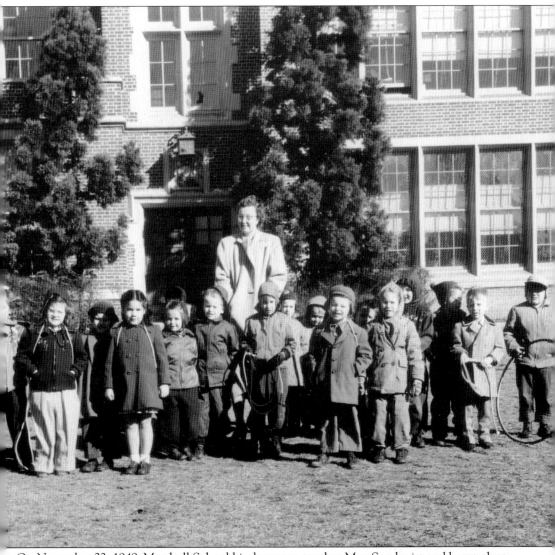

On November 22, 1949, Marshall School kindergarten teacher Mrs. Sandquist and her students pose for a class photograph on the side lawn of the school. Fourth from left, in front, is Susan Zurkow. Many of the students are holding jump ropes, and on the far right, young Jack is holding a new hula hoop made of Marlex, a brand-new durable plastic marketed by Wham-O. Hula hoops went on to become the most profitable fad of the 1950s. (Courtesy Susan Zurkow Frey.)

Varsity team member Jack Feketie aims for the hoop during this 1941 practice session at Seton Hall Preparatory. For 125 years, the "Prep" was located on the Seton Hall University Campus in South Orange. In 1985, the school moved to Northfield Avenue in West Orange. (Courtesy Peter Feketie.)

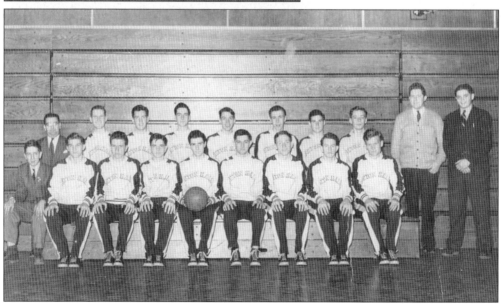

The 1940–1941 Seton Hall Prep Varsity basketball team had a season record of 12 wins and 8 losses. The team gathered on the bleachers for a photograph. Included in this picture are John Lalley, Matt Hayes, Frank Maguire, Vinnie Forlenza (captain), Bill Simmons, Al Briscoe, Frank Coleman, Ed Maciak, "Doc" Turner, Tom McManus, Ray Leddy, Jack Feketie, Dick Hammock, George Haas, John MacDonough, Bill McDermott, Jack Reitemeir (coach), and J. Murray (manager). (Courtesy Peter Feketie.)

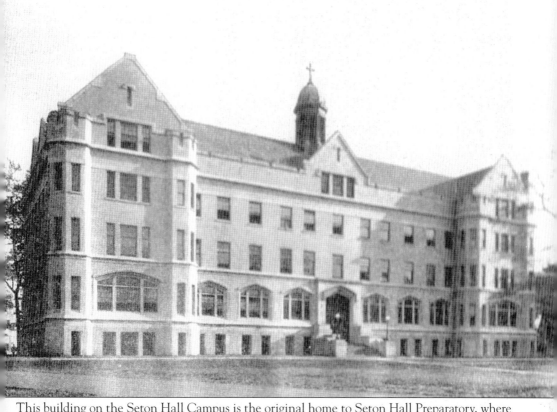

This building on the Seton Hall Campus is the original home to Seton Hall Preparatory, where students studied and played sports. In the 1980s, the school was relocated to a new space in neighboring West Orange.

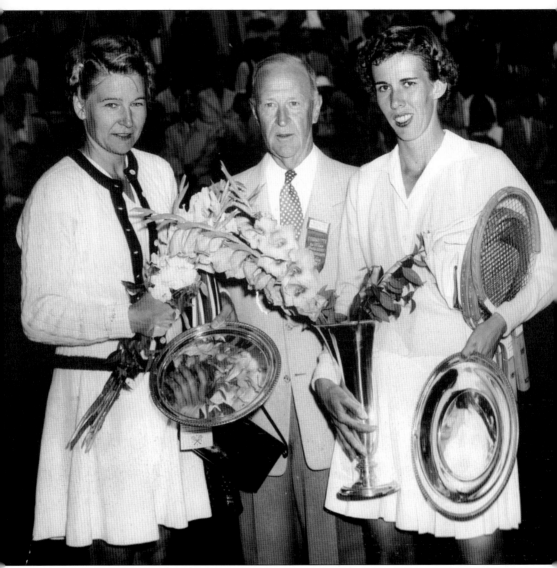

The Orange Lawn Tennis Club hosted a variety of championships throughout the first half of the 20th century. In this c. 1954 photograph, Louise Brough (left) and Doris Hart (Right) receive congratulations and trophies from James Dickey, president of Orange Lawn Tennis Club. Doris Hart is holding the winner's trophy. Each of these tennis greats won 35 major titles in singles, doubles, and mixed doubles during their tennis careers. Both women were later enshrined in the International Tennis Hall of Fame. (Courtesy Orange Lawn Tennis Club.)

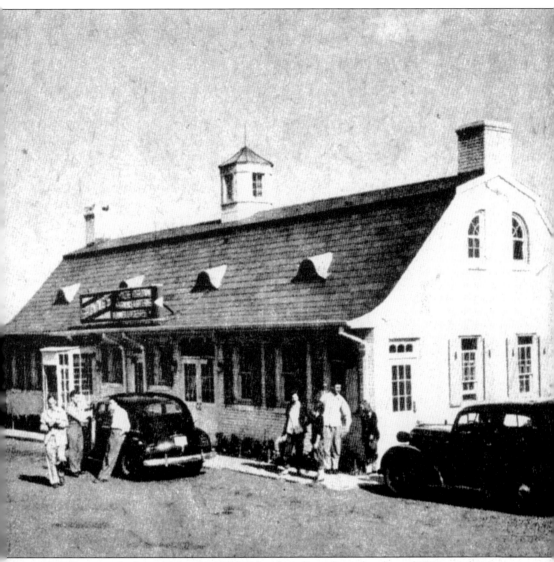

This 1947 photograph shows Columbia High School students from the class of 1949 socializing as they lean on their new cars. They are meeting at one of their favorite spots, Grunings ice-cream shop on South Orange Avenue on the hill, near the Newstead neighborhood. (Courtesy Martha Riker Trundle.)

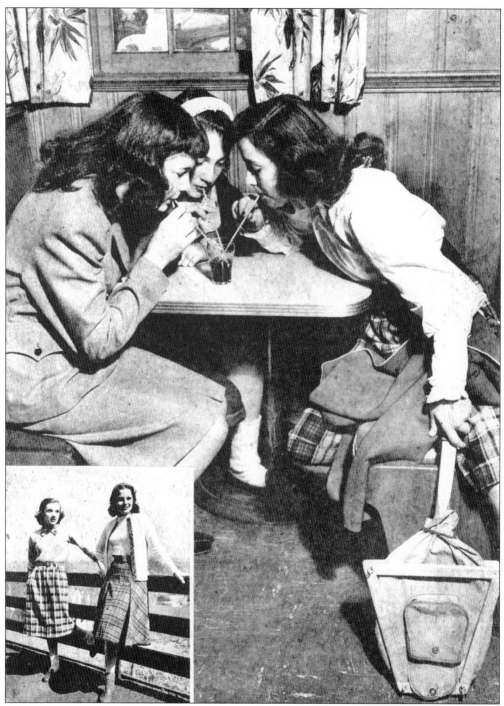

Taken inside Grunings, this August 1947 photograph shows three members of the Columbia High School class of 1949 relaxing in a booth and enjoying an economical refreshment in the form of a very small soda. (Courtesy Martha Riker Trundle.)

COLUMBIA HIGH SCHOOL
Baseball Schedule
1947

Sat.,	April	12	Alumni	Home
Tue.,	April	15	Millburn	Away
Thurs.,	April	17	Bloomfield Tech	Home
Sat.,	April	19	Irvington	Home
Sat.,	April	26	Kearny	Away
Tue.	April	29	Hillside	Home
Sat.,	May	3	West Orange	Home
Tue.,	May	6	East Orange	Away
Sat.,	May	10	New Brunswick	Home
Tue.,	May	13	East Orange	Home
Thurs.,	May	15	Orange	Away
Sat.,	May	17	Kearny	Home
Tue.,	May	20	Montclair	Home
Thurs.,	May	22	Orange	Home
Sat.,	May	24	West Orange	Away
Mon.,	May	26	Central	Home
Fri.,	May	30	Bloomfield	Away

Weekdays	3:30
Saturdays	2:30

The 1947 spring baseball schedule began on Saturday, April 12, with the alumni playing Columbia High School students. The back of the card presents the coaching staff, head coach, team captain, student managers, faculty manager, and the director of athletics. Support for the baseball team was provided by Wilbur C. Crelin, a Maplewood sporting goods retailer. (Courtesy Martha Riker Trundle.)

COACHING STAFF
F. R. Nuttall, Head Coach
T. W. Mellotte, Assistant Coach
CAPTAIN
Ted Fix
STUDENT MANAGERS
Fred Closs, Bus. Mgr.
Ed. Fuhrmeister, Field Mgr.
Bob Williams, Equipment Mgr.
FACULTY MANAGER
E. H. Johnson
DIRECTOR OF ATHLETICS
T. W. Higbee

WILBUR C. CRELIN

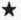

SPORTING GOODS

485 Valley Street Maplewood

SO 2-8031

Columbia High School
ACTIVITIES TICKET 1941-42

Football Home Games
October 4, 2:30 p. m. Plainfield
October 18, 2:30 p. m. Orange
November 1, 2:00 p. m. Montclair
November 15, 2:00 p. m. East Orange
Thanksgiving 10:30 a.m. **West Orange**
 at West Orange

The Columbian

November 14 & 15—Senior Play
March 13 & 14—Junior Night
Baseball Home Games
Home Track Meets

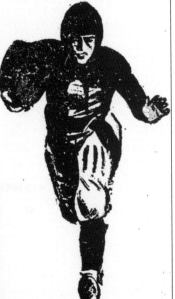

Each activity pass came with its own carrying case, and May Schwebemeyer kept her pass inside the case, which provides the 1941–1942 home game football schedule. Support for the players came in the form of cheers and banners that read, "Plant Plainfield," "Crush Orange," "Maul Montclair", "Kayo W. O.," "Whitewash Westfield," and "Pity the Panthers!" (Courtesy Steve Weintraub and Martha Riker Trundle.)

BUY YOUR ACTIVITIES TICKET NOW!!!

First payment	September 15-22	$1.00
Second payment	October 13	.50
Third payment	October 27	.50
Fourth payment	November 10	.50

Save $1.50 by buying an Activities Ticket! First 1,200 purchasers only will be seated in the football cheering section.

May Schwebemeyer, Columbia High School home room 211, purchased a student activities ticket for the 1940–1941 season to six events at Columbia High School, for a total of $2.75, which includes a 25¢ tax. Schwebemeyer's activity pass enabled her to attend football games, the senior play, junior night, baseball games, track meets, and included a subscription to the *Columbian*, the high school newspaper. The payment plan allows for four payments between September 22 and November 10. (Courtesy Steve Weintraub.)

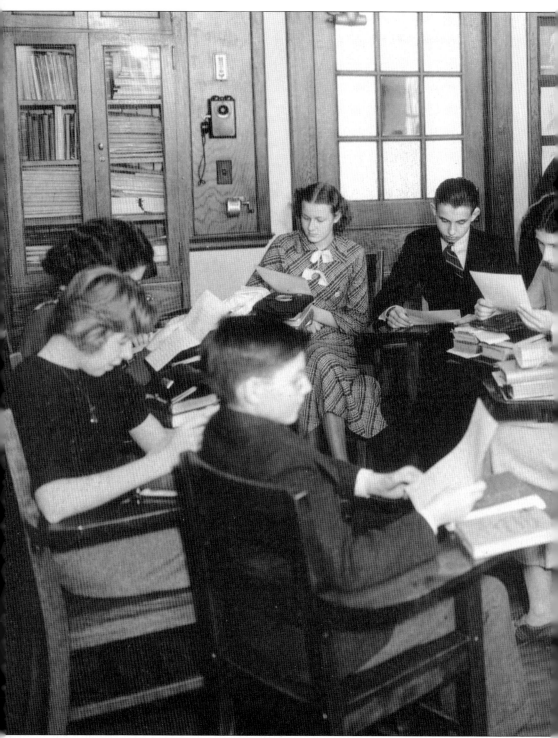

In this 1950s photograph of a Columbia High School English class, students are avidly attending to their assigned reading. One young lady has approached the teacher for help. Behind the teacher are portraits of famous authors, and lining the picture rail are student book reports

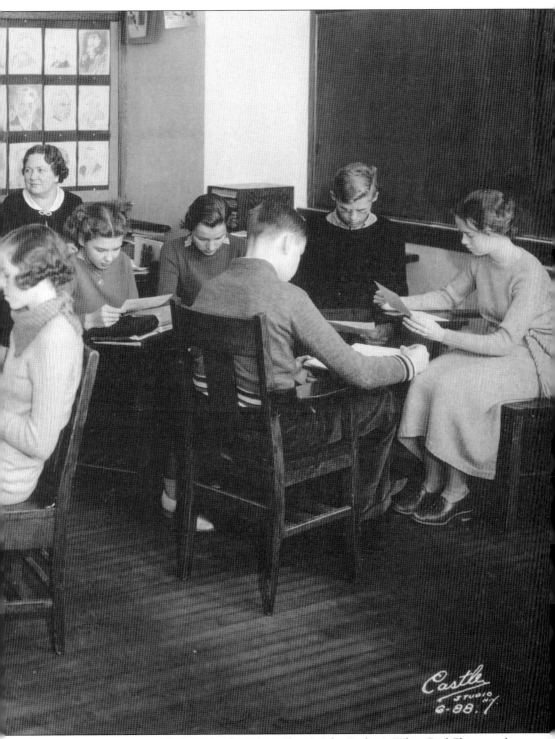

on titles including *Toilers of the Sea, Under Tropic Skies, Moby Dick, A White Bird Flying,* and *Showboat.* (Courtesy Columbia High School Archives.)

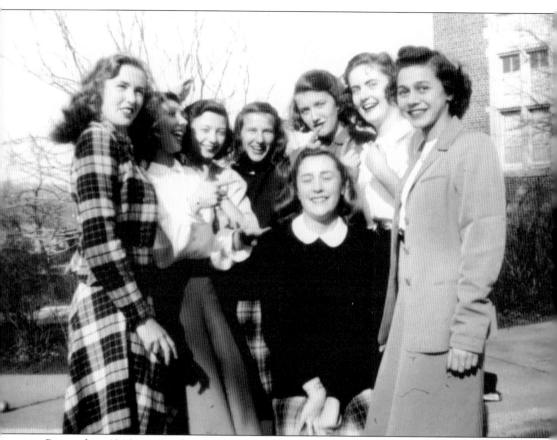

Pictured in 1946 are members of the Columbia High School class of 1949. From left to right are sophomore girls Joan Towey, Joan Ritchings, Martha Riker, Joan LeFrank, Cathie Rissland, Margaret Wogisch, and Francis Denardo. Connie Hetzel kneels in front. (Courtesy Martha Riker Trundle.)

Six

NEW SPORTS AND NEW MUSIC
1960–1979

Columbia High School is where the sport ultimate (often called ultimate Frisbee) was created. In 1968, student newspaper editors Mark Epstein, Buzzy Helring Jr., and Joel Silver began playing Frisbee football at Columbia High School. In the summer of 1969, Epstein proposed a rule that made it illegal to run with the frisbee, dramatically changing the game into new sport: ultimate Frisbee. Students began playing the "ultimate sports experience," and soon ultimate made it to college campuses. Ultimate founders graduated in 1969. Today ultimate is played in 42 countries, and it is estimated that at least 100,000 people play the sport worldwide, with about half in the United States.

Orange Lawn Tennis Club continued to host Tennis Week, a well-known destination for premier tennis tournaments. Players were assigned to host families, who provided them with room and board during the competition. It was both economical for players and exciting for village residents.

Since 1914, Cameron Field has been a free playground for all South Orange residents. In 1969, the village proposed that a new subscription pool complex be built within the Cameron Field property. Village residents fought the plan (Cameron's initial deed stipulated that the use of the land was to be free to the public). The case landed in the New Jersey Supreme Court, and the homeowners prevailed. In 1973, residents splashed their way into the new $400,000 swimming complex. More than 30 years after that victory, South Orange residents swim for a nominal annual fee of $15 per person. The South Orange pool complex is named in memory of resident Peter S. Connor who served in the U.S. Marine Corps. Connor died in 1966 while serving in Vietnam. He posthumously received the Medal of Honor and the Purple Heart.

The 1960 population in South Orange was estimated to be 16,175. Village presidents were William C. Kreuse, William S. Doyle, Charles D. Deubel, and Brian C. Conlan.

Making headlines was news about the first human heart transplant, Neil Armstrong being the first human to walk on the Moon (1969), the discovery of the molecular structure of DNA by Watson and Crick, and the *Apollo XIV* Moon landing. The 26th Amendment was passed, lowering the national voting age to 18, Pet Rocks became a fad, and gasoline shortages led to daylight savings time in order to save fuel. *Viking I* landed on Mars and sent photographs to earth, *Voyager* sent photographs of Jupiter to earth, and two amateur electronics enthusiasts developed the Apple computer in a California garage.

Inventions included the stealth bomber, IBM's PC, radioactive carbon (for dating prehistoric objects), the food processor, liquid crystal display screens, Hacky Sack, the Post-it Note, cellular telephones, and disposable razors.

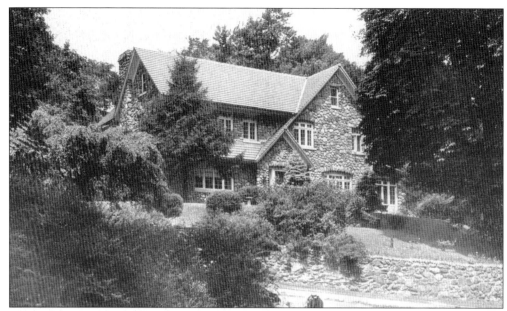

This rubble stone house is located at 105 North Ridgewood Road, across from the duck pond. In the 1960s, it was home to Richard J. Brown, M.D., a village trustee who is also described as "one of the State's outstanding physicians." Dr. Brown was known to make house calls when new babies were about to arrive. Upon his arrival at the expectant parents' home, he typically instructed the fathers to begin gathering newspapers for the delivery. (Courtesy Eleanor Farrell and South Orange and Maplewood in Pictures.)

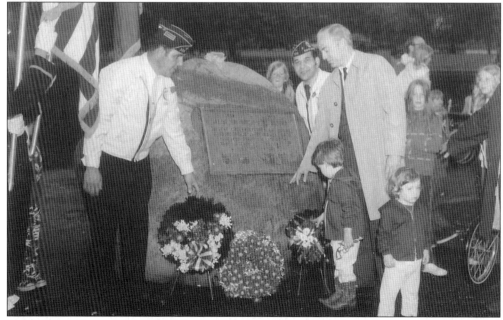

South Orange has a long and rich history of recognizing its residents who have given their lives or served in protecting their nation's freedom. In this c. 1960s photograph, a village official has just laid wreaths during the Memorial Day ceremony at the Memorial Rock located by the South Orange Duck Pond on North Ridgewood Road. (Courtesy of the Zuzuro family.)

A testimonial dinner was held at the Crystal Lake Casino in West Orange in honor of police chief F. Byron Fitzsimmons on February 27, 1968. Fitzsimmons served the village as chief of police for more than 40 years. He joined the force in 1924 and made detective in 1938; in 1942, he earned the rank of sergeant and later in the same year, lieutenant. In 1944, he was promoted to captain. From 1950 to 1968, he served as chief. (Courtesy South Orange Public Library.)

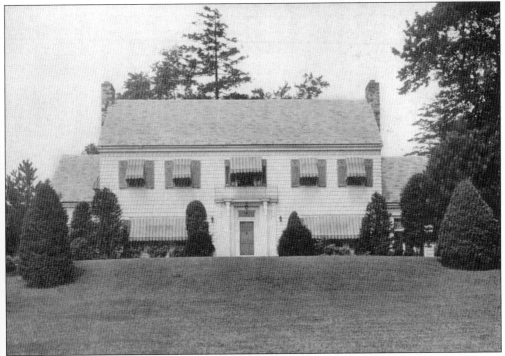

This c. 1960 photograph shows the clapboard center hall Colonial residence of Judge Edwin C. Caffrey. The property is located on North Ridgewood Road. (Courtesy Eleanor Farrell.)

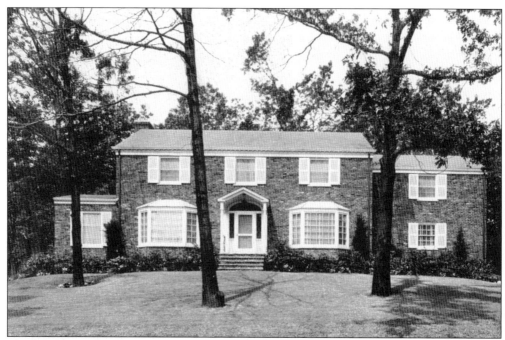

This brick center hall Colonial home with matching bay windows was home to Harry L. Huelsenbeck. Located on Glenview Road, in the Newstead section of South Orange, the home was likely built in the early 1960s. (Courtesy Eleanor Farrell.)

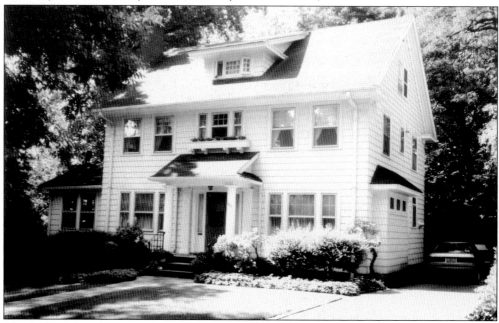

The backyard of this 1940s home of the Feketie family at 280 Forest Road was adjacent to Orange Lawn Tennis Club. During Tennis Week at Orange Lawn Tennis Club, local families hosted players who stayed with them free of charge. Each year through the 1960s and 1970s, the Feketie family hosted a player at their home because it was so close to the tennis club. (Courtesy Peter Feketie.)

Dick Stockton lines up for a return in this 1977 match at Orange Lawn Tennis Club. For many years, Orange Lawn hosted tournaments that drew top names in tennis. When he was not playing at Orange Lawn, Stockton earned an impressive record that included reaching the semifinals of Wimbledon in 1974 and reaching the quarterfinals of the U.S. Open in 1976 and 1977. Stockton played on the U.S. Davis Cup Team five times (1973, 1975, 1976, 1977, and 1979), including the U.S. Davis Cup Championship Team in 1979. He was the 1977 U.S. Pro Indoor Champion and was a semifinalist in the 1978 French Open. (Courtesy Orange Lawn Tennis Club.)

ILIE NASTASE - CHAMPION
MEN'S SINGLES, (EASTERN GRASS COURT CHAMPIONSHIPS, 1972, '75
(TENNIS WEEK OPEN 1976

During Tennis Week Open in 1976, Ilie Nastase is shown here on August 19 playing Roscoe Tanner in the final set of the men's singles. Nastase held the title of Eastern Grass Court Champion in 1972 and 1975; both events were held at Orange Lawn Tennis Club. (Courtesy Orange Lawn Tennis Club.)

Ball boy Michael Feketie keeps his eye on the ball as Marty Riessen takes a tumble on the court during Tennis Week at Orange Lawn Tennis Club around 1975. Mark Riessen ranked No. 11 in the world in 1974. Over his career, Riessen won six singles titles, 53 doubles titles, and was a member of the U.S. Davis Cup team in 1963, 1965, 1967, 1973, and 1981. Dunlop named one of its racquets the "Marty Riessen." (Courtesy Peter Feketie.)

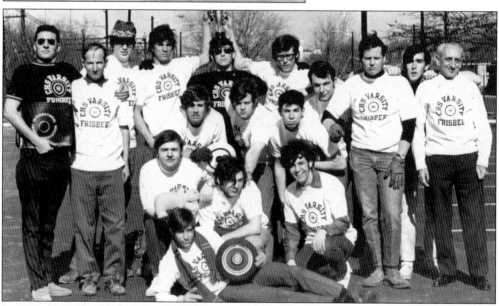

In 1969, Columbia High School (CHS) students Mark Epstein, Buzzy Hellring, and Joel Silver (in black t-shirts) created the game of ultimate (sometimes called ultimate Frisbee). Wearing their game faces for this photograph is the CHS Varsity Frisbee Squad of 1969–1970: from left to right, (stretched out in front) Steve Schwartz with Frisbee Master model; (first row, kneeling) Fred Appelgate, Howard Straubing, and Steve German; (second row, bending forward) Tom Corwin (with Frisbee Pro model), David Medinets, and David Leiwant; (third row) captain Joel Silver, head coach Cono Pavone (CHS janitor), Bob Mittlesdorf, Jonny Hines, Buzzy Hellring (with trophy over head), Joe Staker, Paul Brenner, Tom Carr, Mark Epstein, and general manager Alexander Osinski (CHS security guard). Players missing from the photograph include Phil Dempsey, Steve Stern, Chas. Leiwant, Evan Sorett, David Reed, and Marty Berman. (Courtesy Mark Epstein.)

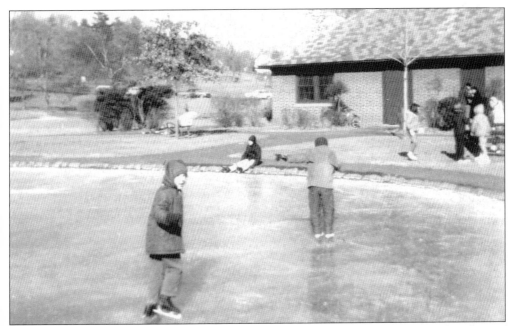

Wondering when the pond would freeze was a waiting game each winter for skate enthusiasts of every age and of all levels of ability. It was a frozen day in March 1966 when Peter Feketie (left) tied on his hockey skates and took a turn on the duck pond. Peter is bundled up in his hooded parka and wears heavy gloves. (Courtesy Peter Feketie.)

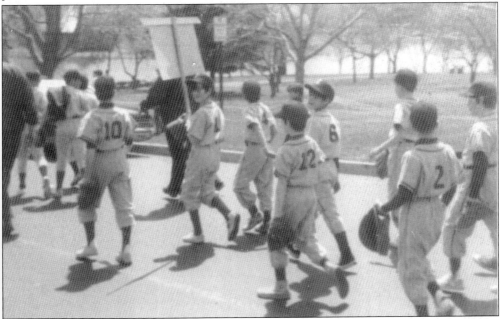

Each year, on opening day for South Orange baseball, Little League players carry team signs in a parade. The players gather at Grove Park, walk west on South Orange Avenue and turn north onto North Ridgewood Road. They walk to Mead Street, turn right and end up at Cameron Field. In this 1971 photograph, Peter Feketie carries the sign for their team, Carteret Savings. That year they were undefeated champions. (Courtesy Peter Feketie.)

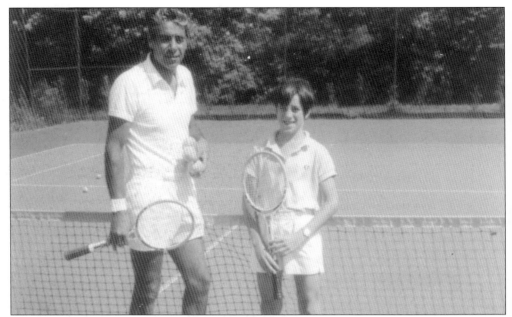

Pancho Gonzales (left) poses with Peter Feketie on the clay courts at Orange Lawn Tennis Club, around 1972. In the days of the wooden racquet, Poncho Gonzoles's 112-mile-per-hour serve was the fastest ever recorded. Gonzales was known as the No. 1 professional tennis player in the world for most of the 1950s and early 1960s Completely self-taught, he was also a successful amateur player in the late 1940s, twice winning the United States Championships. The tempestuous Gonzales is still widely considered to be one of the all-time great tennis players. Prior to the open era, he was considered by many observers to be the greatest player in the history of the game. (Courtesy Peter Feketie.)

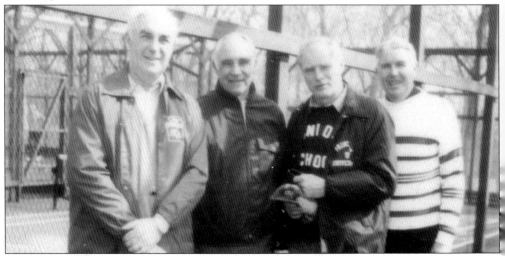

The sport of platform tennis was invented in 1928 in Scarsdale, New York. It is a winter sport developed by Fessenden Blanchard and James Cogswell, who wanted an outdoor game to help them keep up their tennis skills over the winter months. Orange Lawn Tennis Club built several platform tennis courts, and in this c. 1978 photograph, Jack Feketie (left) and New Jersey governor Brendan Byrne (second from right) are ready to take to the courts. Democrat governor Byrne served as New Jersey's 47th governor, from 1974 to 1982. (Courtesy Peter Feketie.)

Max Weinberg, who grew up on Montrose Avenue in the Montrose Park Historic District of South Orange, began playing drums at Marshall School and continued to perfect his talent through Columbia High School. Famous for being Bruce Springsteen's drummer, and since 1993 music director and performer on "Late Night" with Conan O'Brien, Weinberg still returns to South Orange. In 2004, Weinberg served as chair of the Montrose Park Historic District Association's 10th-Anniversary Gala, held at the Newark Museum, where he shared his fond memories of growing up in Montrose Park.

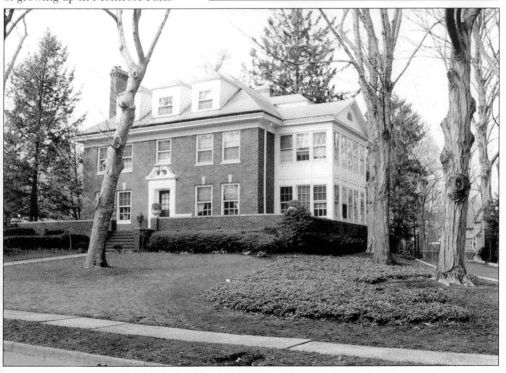

Each year children of all ages take advantage of Mother Nature's winter storms by bringing their sleds to Flood's Hill. Although the William Redmond family owned this property in the late 1800s, this popular hill was named Flood's Hill because he rented the land to Mr. Flood, who grazed his Jersey cows on the hill. Today the village owns the property, but it is still identified as Floods Hill.

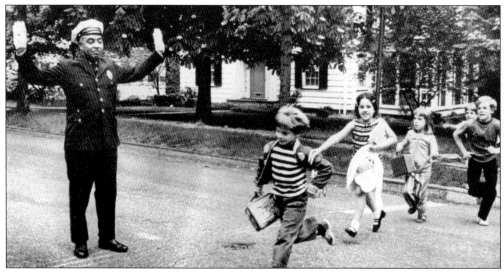

Making sure elementary school children get to school safely is a police officer who is on school crossing duty. The number of school-age children significantly increased during World War I, but since it was considered unpatriotic to divert funds from the war effort, school building was put off. Finally, in the 1920s, South Orange built five elementary schools. Marshall School was built in 1922, and the First Street School was built in 1923. Both the Tuscan and Montrose Schools were added in 1924. And South Mountain School was built in 1929. No other elementary schools were built until 1955, when the new elementary school in Newstead opened its doors. (Courtesy Eleanor Farrell.)

BIBLIOGRAPHY

Bettelle, J., *The Unusual School System of a Suburban Community*. American School and University: New York, NY. (First Edition, pp 81–85) Bullenheim Pub. Co., 1928/1929.

Fonler, T. *Bird's Eye View of South Orange, New Jersey*. Milwaukee, WI: D. Brenner and Co., Lithographers, 1887.

Foster, H. *The Evolution of the School District of South Orange and Maplewood New Jersey 1814-1927*. Geneva, NY: The W. F. Humphrey Press, 1930.

Garis, H. R. *Uncle Wiggily's Story Book*. New York, NY: Platt and Munk Publishers, 1939.

Mueller, A. *Atlas of the Oranges, Essex County, New Jersey*. Philadelphia, PA: A. H. Mueller Publisher, 1911.

News-Record. "South Orange, 1869-1969." A supplement to the *News-Record* of Maplewood and South Orange. Union, NJ: Worrall Community Papers, October 2, 1969.

Rivas, M. E. *Beautiful Jim Key: The Lost History of a Horse and a Man Who Changed the World*. New York, NY: William Morrow an Imprint of HarperCollins Publishers, 2005.

South Orange Record, "Village of South Orange – 'Gem of the Oranges,' Photographic Views and a Short Historical Sketch." South Orange, NJ: South Orange Publishing Co., 1922.

Taber, T. & Taber III, T. *The Delaware, Lackawanna & Western Railroad in the Twentieth Century [The Road of Anthracite] 1899 - 1960*. Muncy, PA: Thomas T. Taber III, 1981.

Township of South Orange Village. *South Orange NJ Report to the People*. South Orange, New Jersey: Township of South Orange, 1971.

Welk, N. *Images of America South Orange*. Charleston, SC: Arcadia Publishing, 2002.

Welk, N. *Portraits of Ramsey*. Sewell, NJ: The Ramsey Historical Association in cooperation with Behr Publishing, LLC., 2005.

Whittemore, H. *The Founders and Builders of the Oranges 1666-1896*. Newark, NJ: I. J. Hardham Printer and Bookbinder, 1896.

Zakalak Associates. *Montrose Park Historic District, South Orange, New Jersey Nomination to the National Register of Historic Places*. United States Department of the Interior National Park Service, 1997.

ACROSS AMERICA, PEOPLE ARE DISCOVERING SOMETHING WONDERFUL. *THEIR HERITAGE.*

Arcadia Publishing is the leading local history publisher in the United States. With more than 3,000 titles in print and hundreds of new titles released every year, Arcadia has extensive specialized experience chronicling the history of communities and celebrating America's hidden stories, bringing to life the people, places, and events from the past. To discover the history of other communities across the nation, please visit:

www.arcadiapublishing.com

Customized search tools allow you to find regional history books about the town where you grew up, the cities where your friends and family live, the town where your parents met, or even that retirement spot you've been dreaming about.